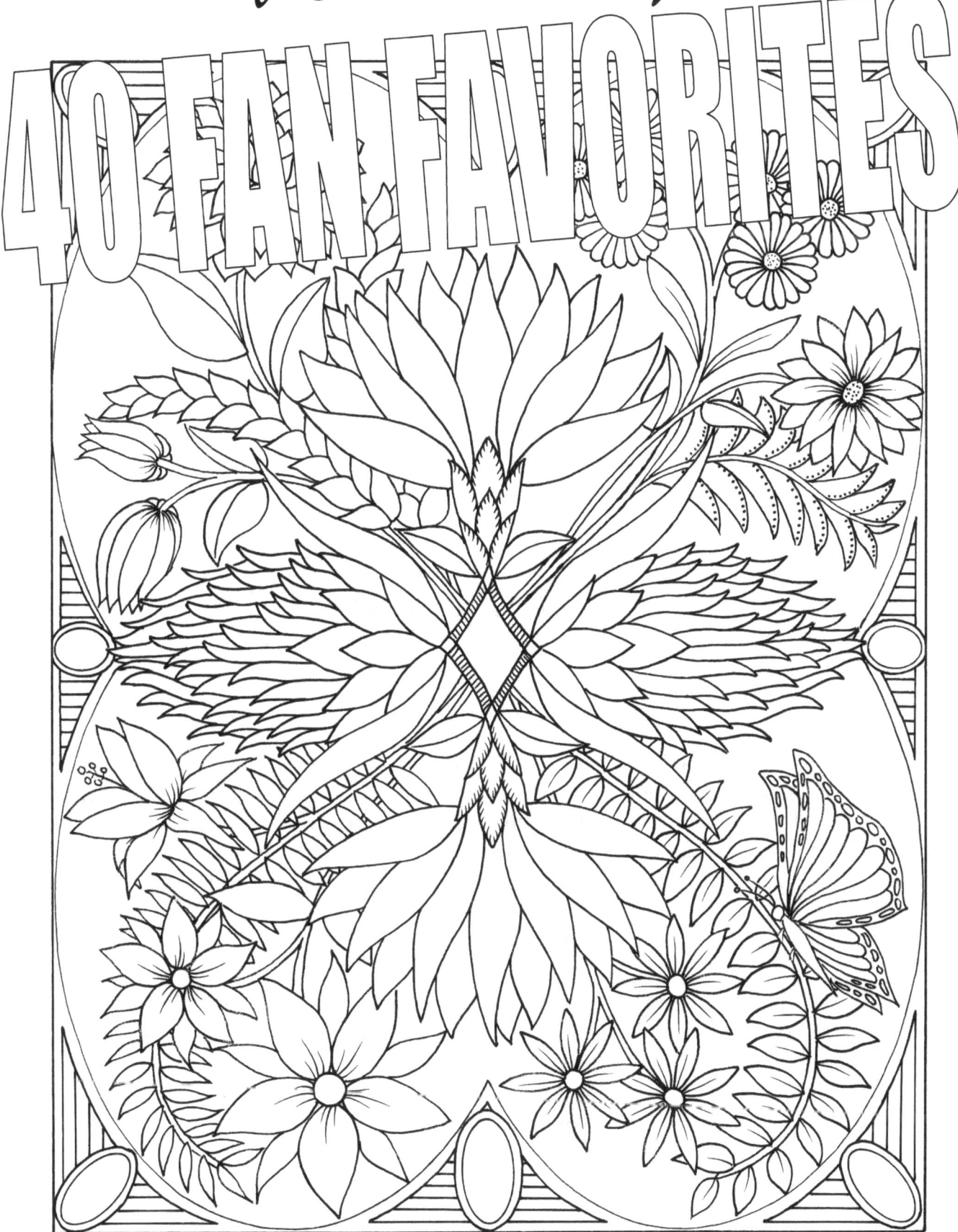

Copyright © 2019 C. L. Aldridge
The Best of C. L. Aldridge ~ Fan Favorites (Vol. 1)

All rights reserved.

In accordance with the U.S. Copyright Act of 1976, the scanning, uploading, and electronic sharing of any part of this book without the permission of the artist/author constitutes unlawful piracy and theft of the artist/author's intellectual property. If you would like to use material from the book (other than for your own personal coloring or review purposes), prior written permission must be obtained by contacting the artist/author at:

CLAldridgeArt@gmail.com

Visit me on Facebook at: www.facebook.com/CLAldridgeArt
Join my Group on Facebook: C. L. Aldridge's, Coloring in Bloom - Coloring Club
Visit my website at: www.CLAldridgeArt.com
Follow me on Twitter and Instagram and YouTube: @CLAldridgeArt
Join me on YouTube for a Live Color & Chat with the Artist at 2p.m. EST every Sunday.

Thank You for your support of the artist/author's rights.

ISBN: 9781095926956

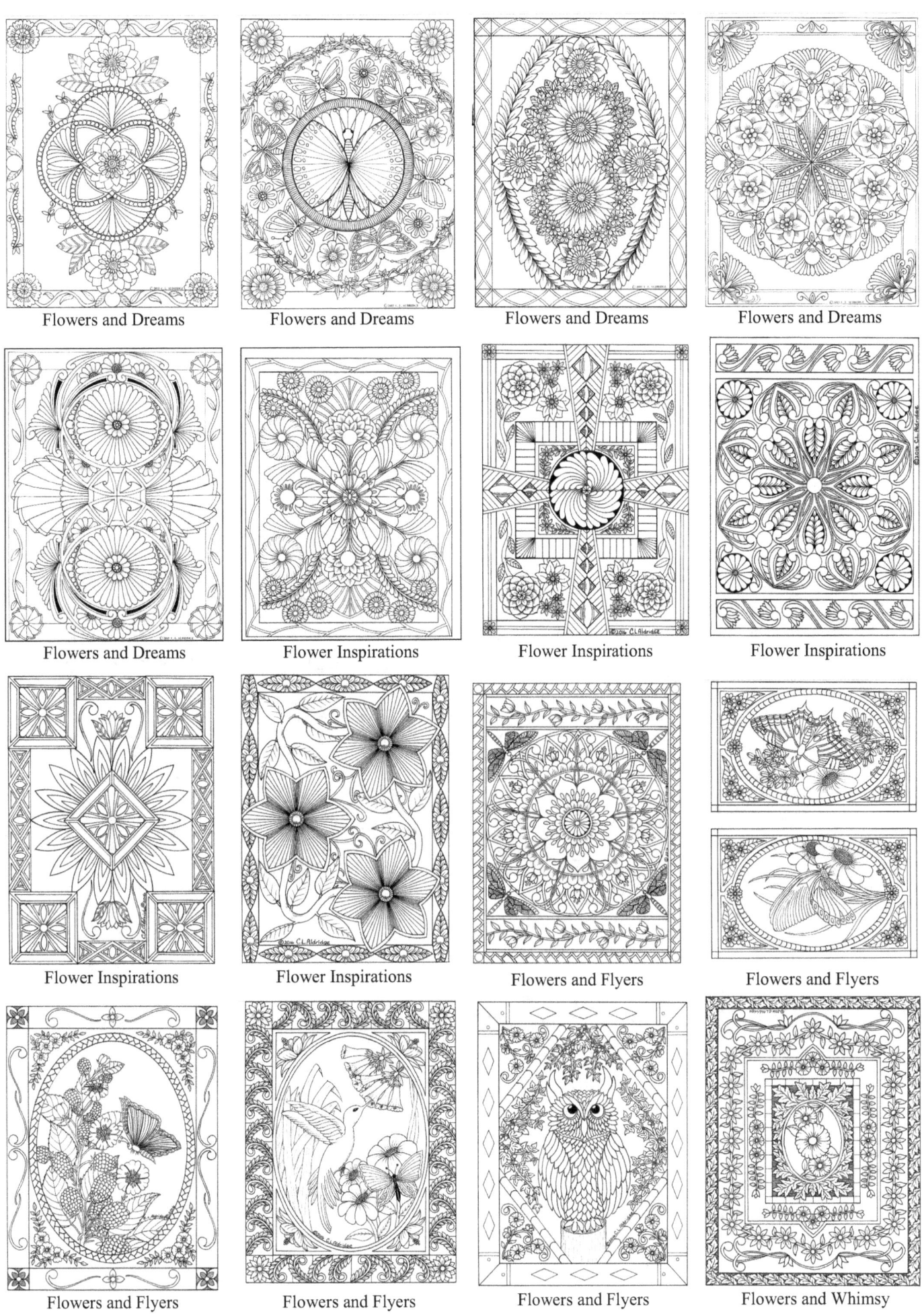

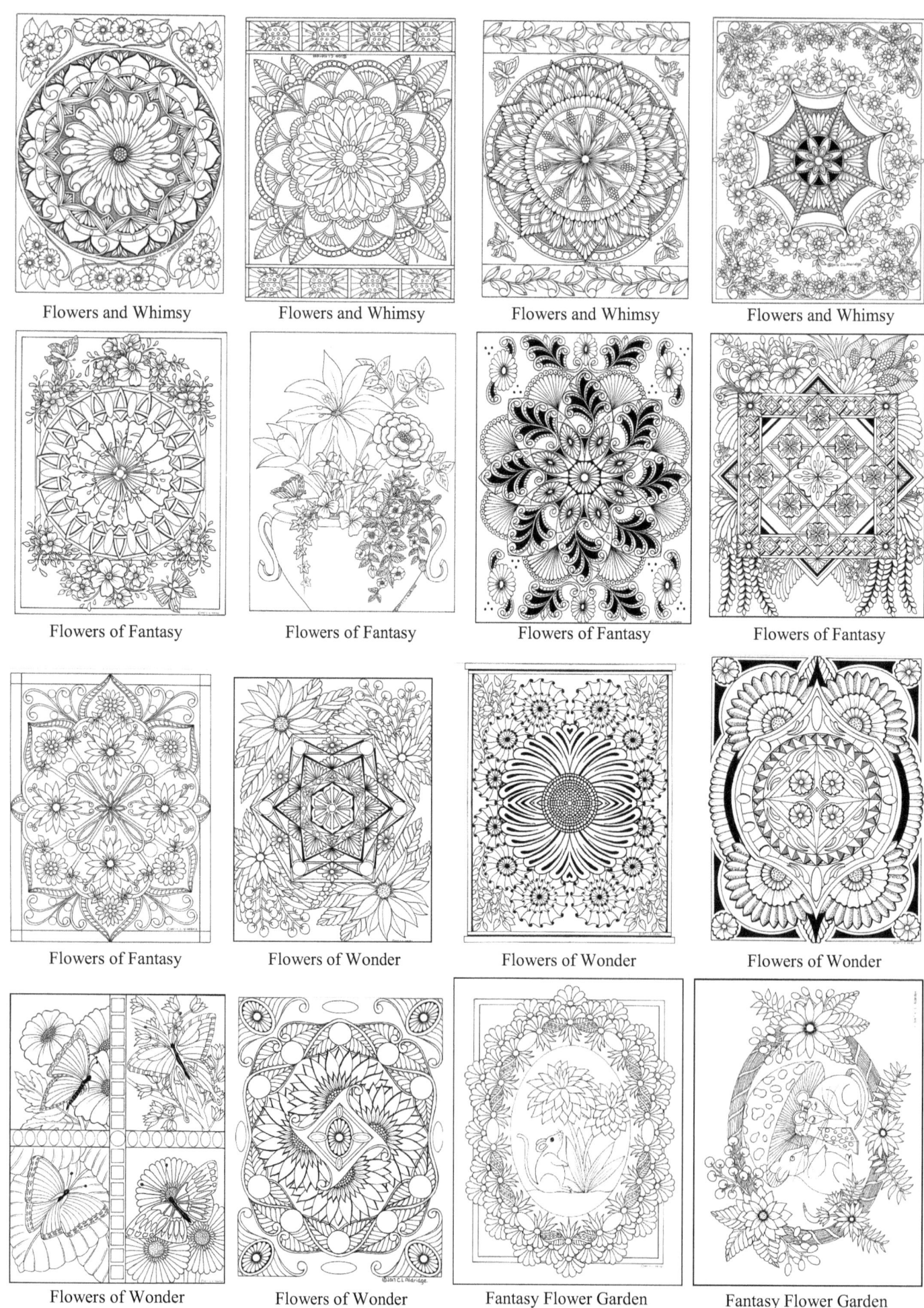

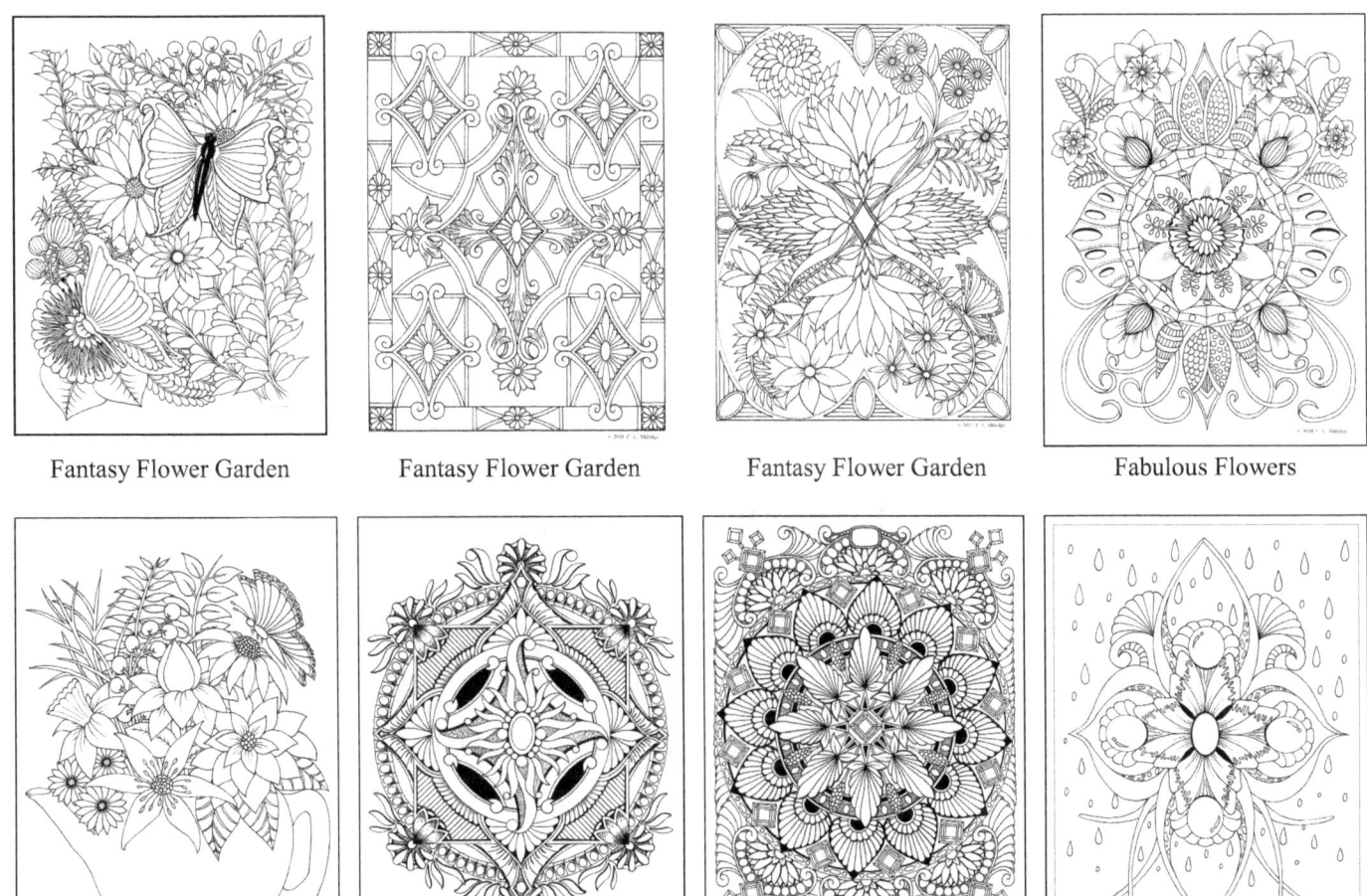

| Fantasy Flower Garden | Fantasy Flower Garden | Fantasy Flower Garden | Fabulous Flowers |
| Fabulous Flowers | Fabulous Flowers | Fabulous Flowers | Fabulous Flowers |

Also by C. L. Aldridge

Flowers and Dreams
A Coloring Book of Beautiful Botanical Symmetry

Adult Coloring Book of Flower Inspirations
Beautiful Floral Patterns, Botanical Mandalas, Gemstones, Lovely Words and More!

Flowers and Flyers
Adult Coloring Book of Flowers, Songbirds, Hummingbirds, Butterflies, Owls, Ornamentals and More!

Travel Size Book of Flowers, Birds Butterflies and More!
Your Coloring Book for the Road.
(Measures 6" x 9", just the right size to tuck in a purse, a travel bag or a desk drawer.)

Flowers and Whimsy
Adult Coloring Book of Fun to Color Ornamental Floral Patterns, Whimsical Butterflies, Dragonflies and More!

Flowers of Fantasy
A Coloring Book of Fantastical Floral Designs

Flowers of Wonder
A Coloring Book of Fabulous Fantasy Flowers

Fantasy Flower Garden
Adult Coloring book of Fantastic Flowers and Friendly Animals

Fabulous Flowers
A Coloring Book of Flowers, Imagination and Symmetry

The Best of C. L. Aldridge - MANDALAS
A Coloring Book of 48 Favorite Floral Mandalas

**EXTRAORDINARY COLORING BOOKS
FOR EXTRAORDINARY PEOPLE**

This book has been created as a sampler edition and is
therefore dedicated to the friends I haven't yet met; And
to those who just like to color something pretty!

* * * *

Special Thanks to Virginia Sanders Cole
for once again allowing me to feature
some of her beautiful coloring work
on the cover of this book.

* * * *

IMPORTANT INFORMATION FOR USING THIS BOOK

- This book contains 42 original design hand-drawn illustrations to color, each has been printed SINGLE SIDED (back is blank).

- The pages are printed on #60 lb bright white paper which performs well for all brands of colored pencils and crayons, without the need of a blotter page.

- To avoid any "Uh Oh's" and the associated disappointment, **Marker and Gel Pen users are STRONGLY ENCOURAGED to USE A BLOTTER SHEET** behind the drawing to avoid any possibility of bleed through to the next page. Several blank blotter and color testing pages are provided at the end of this book.

- Most IMPORTANT of all: Relax, have fun, stand-up and stretch often, and remember that sometimes the most beautiful things come from what we think at first are mistakes, but which turn out to be art's way of working magic!

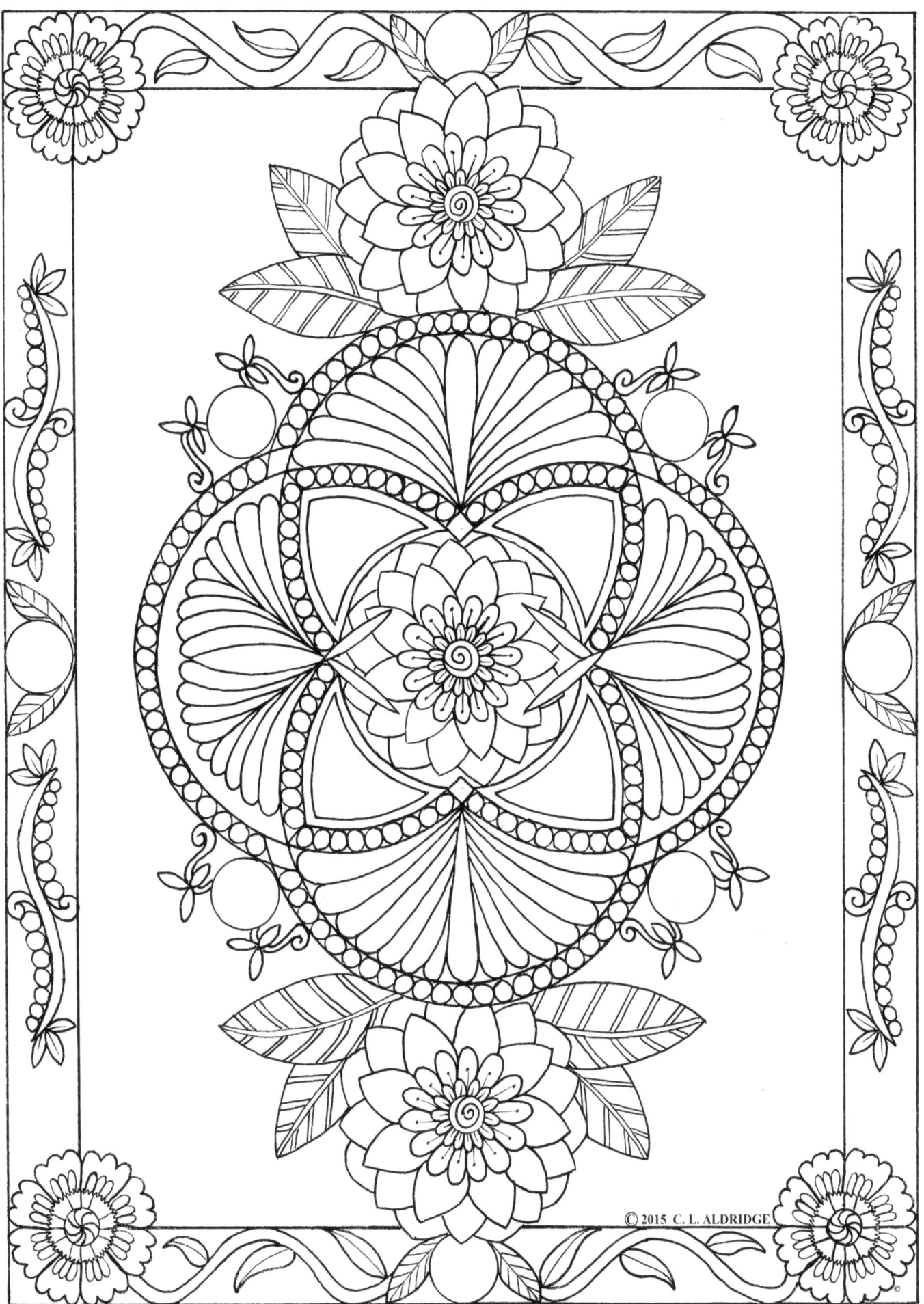

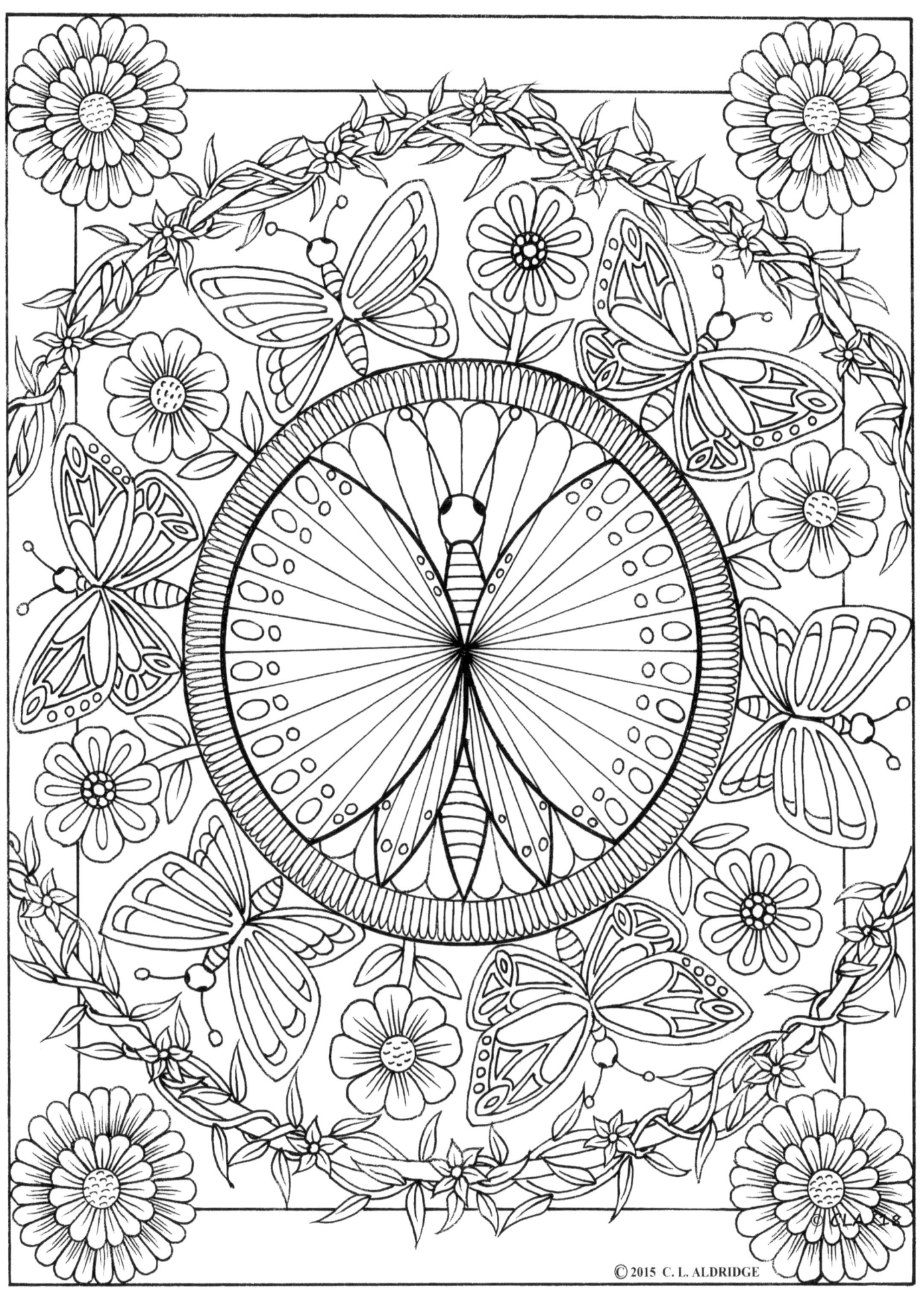

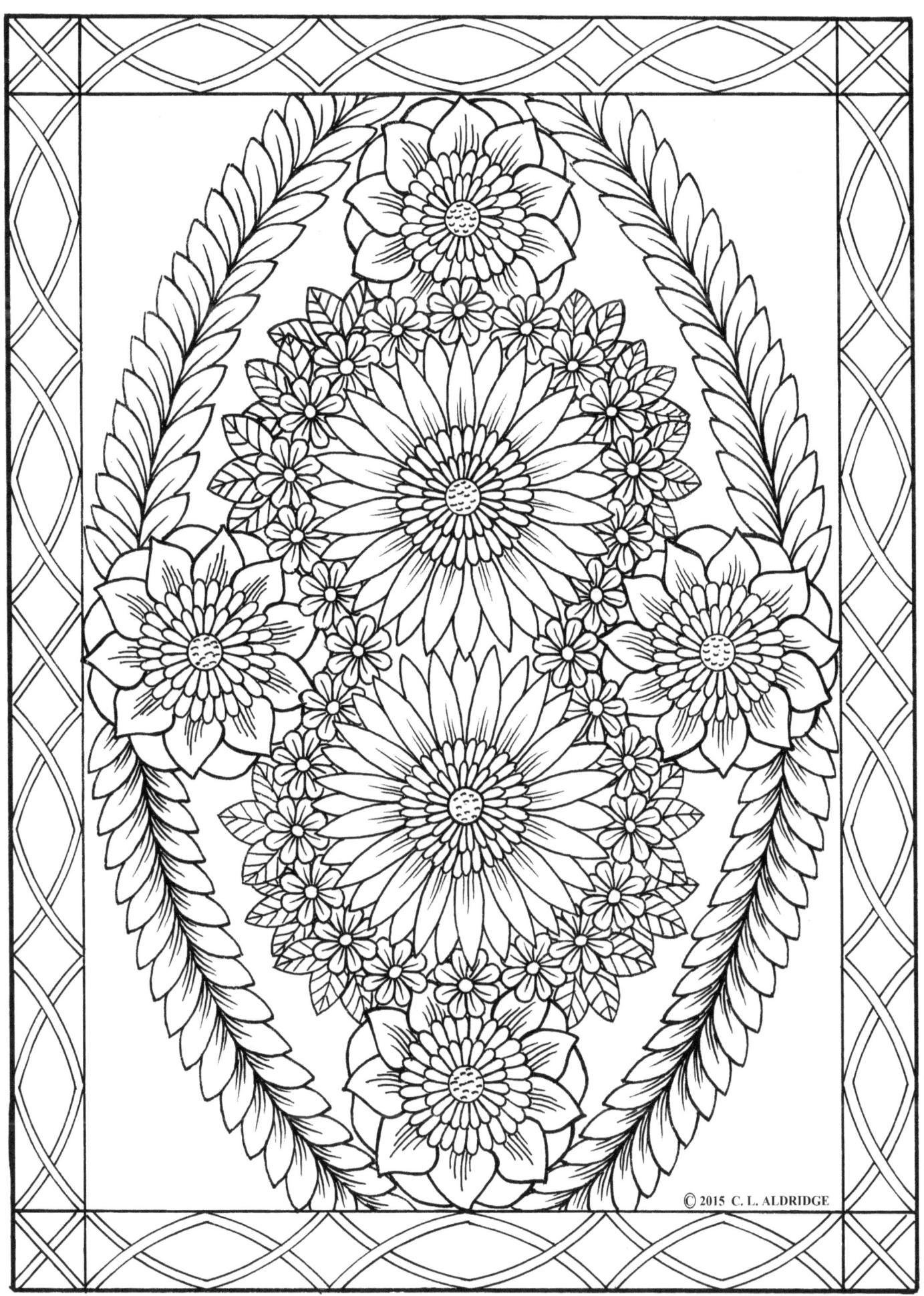

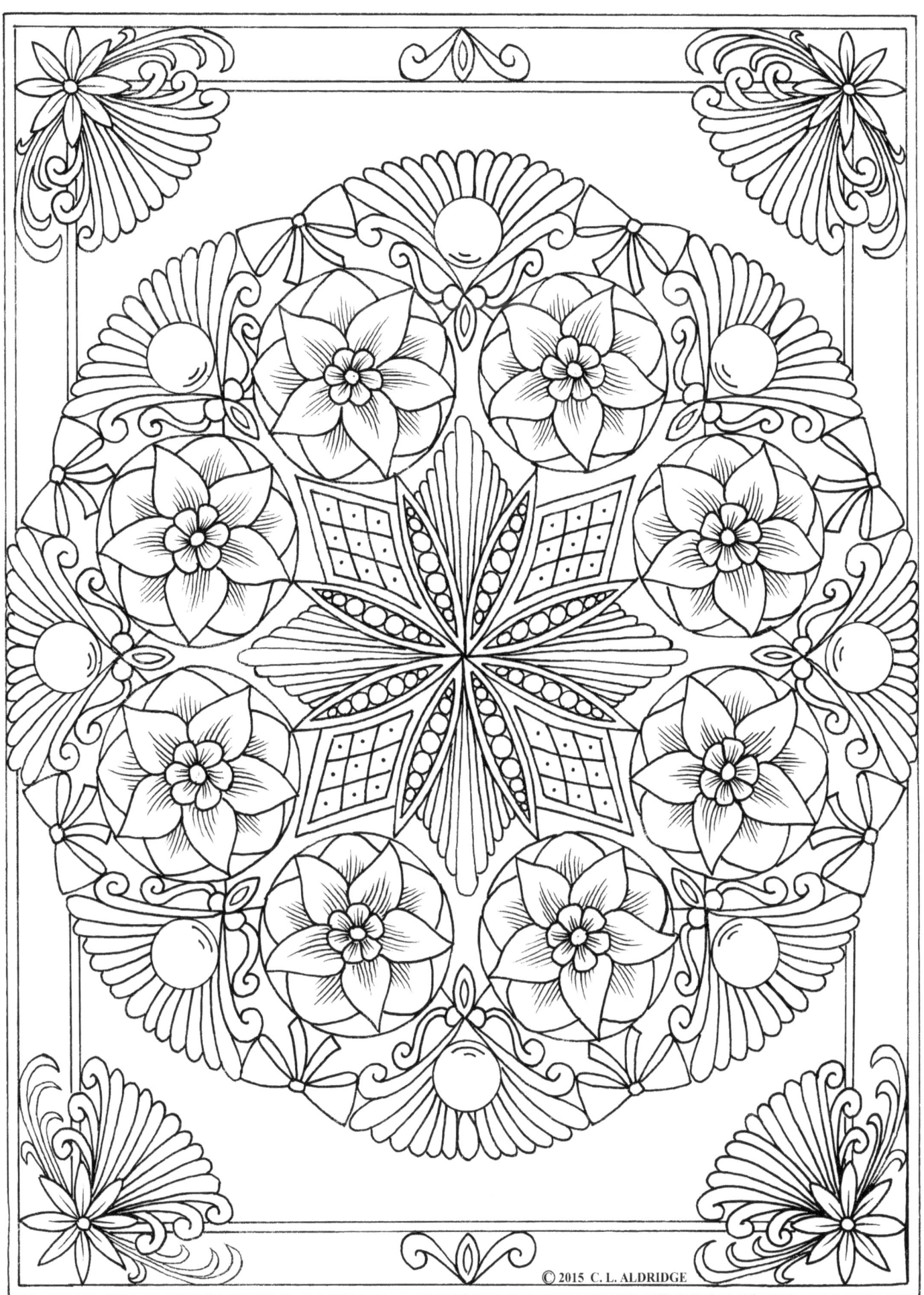

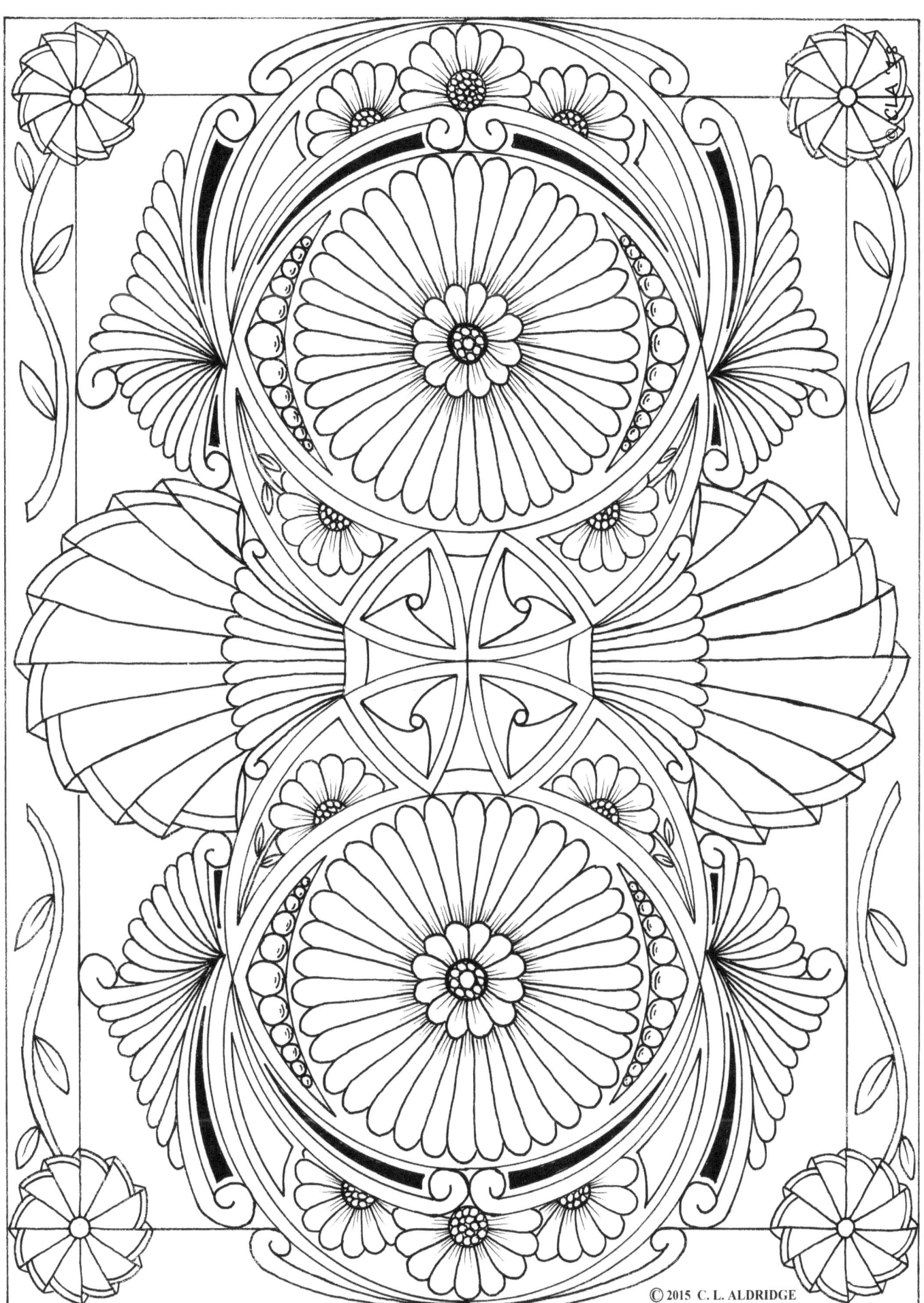

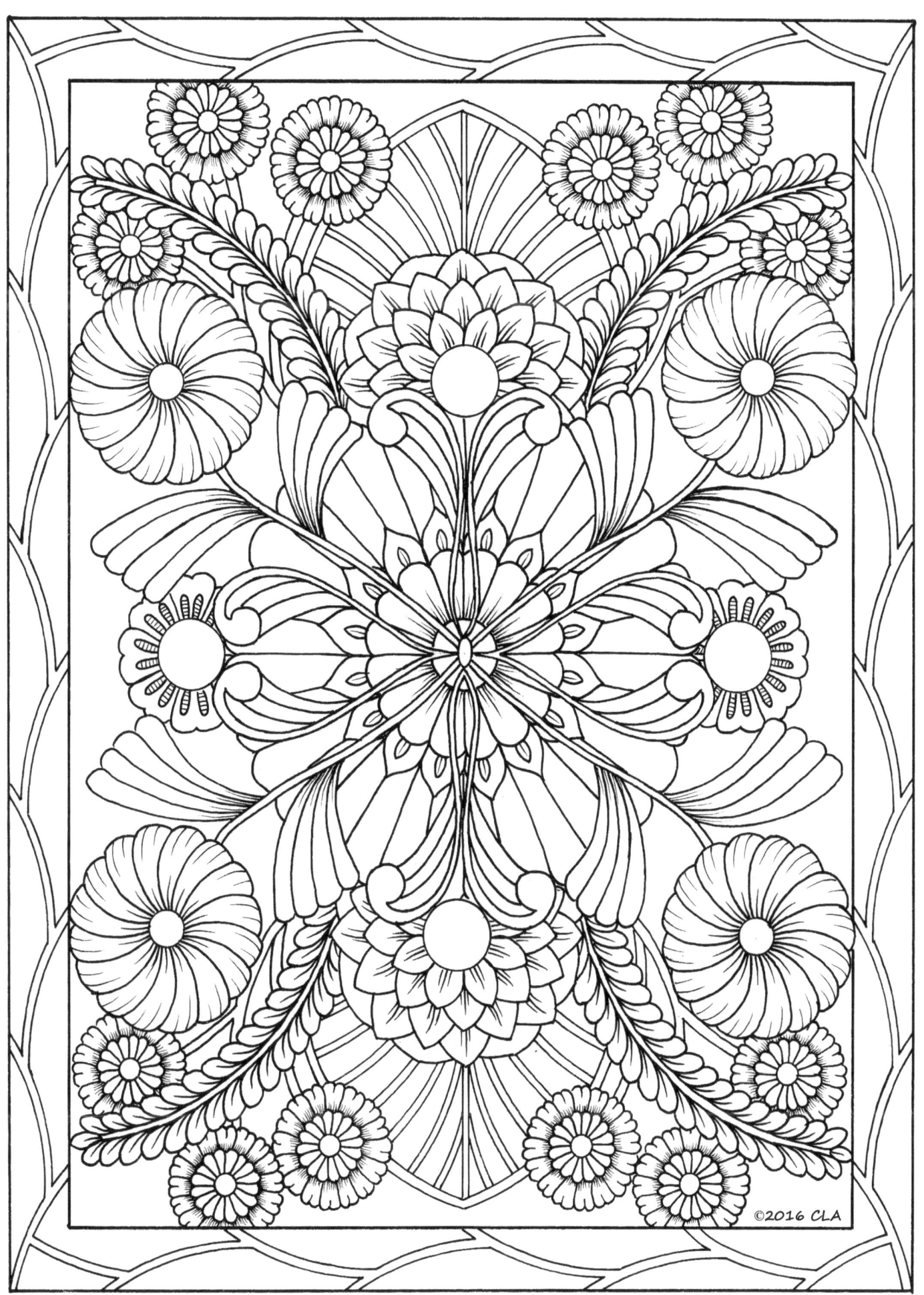

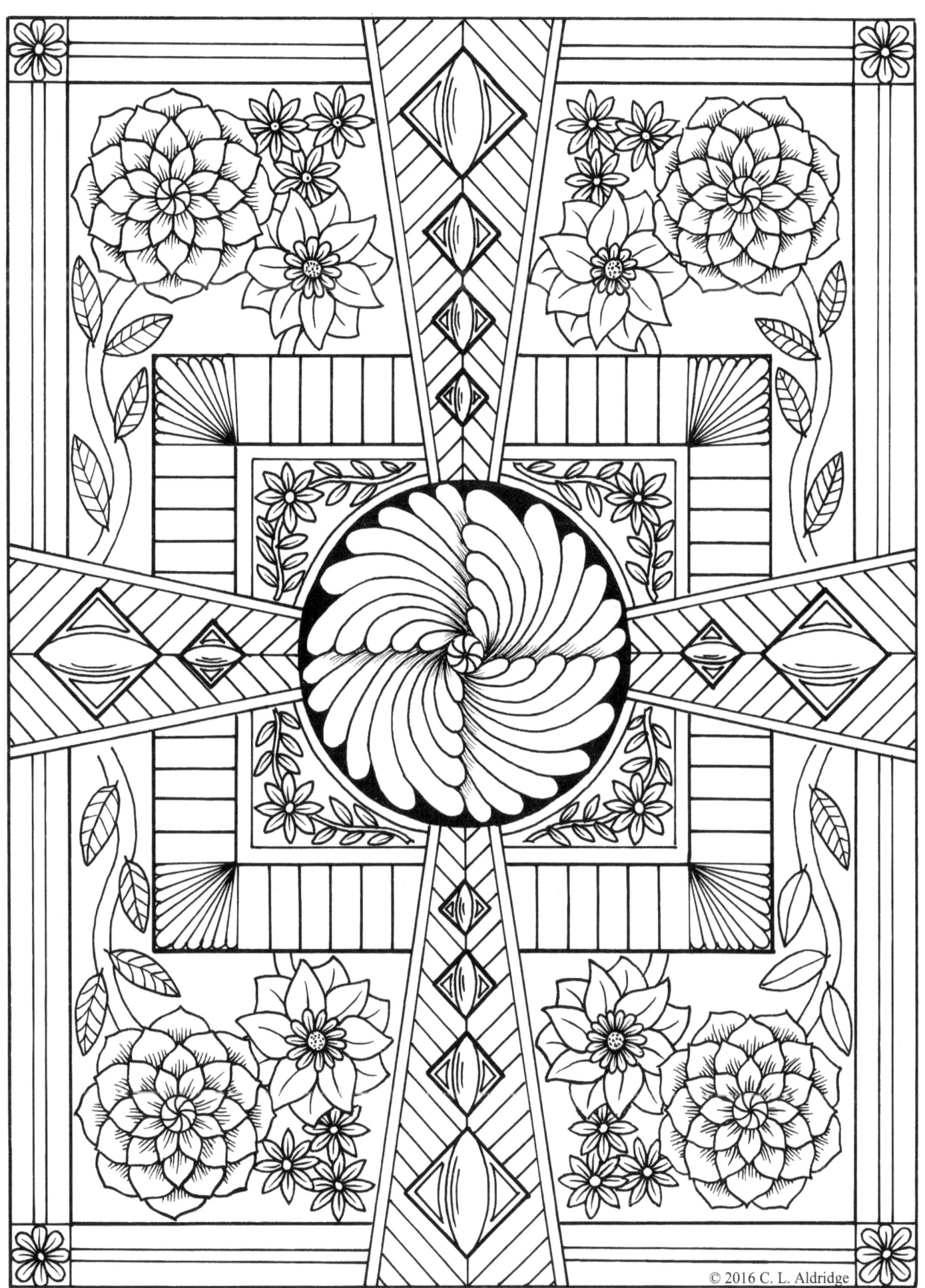

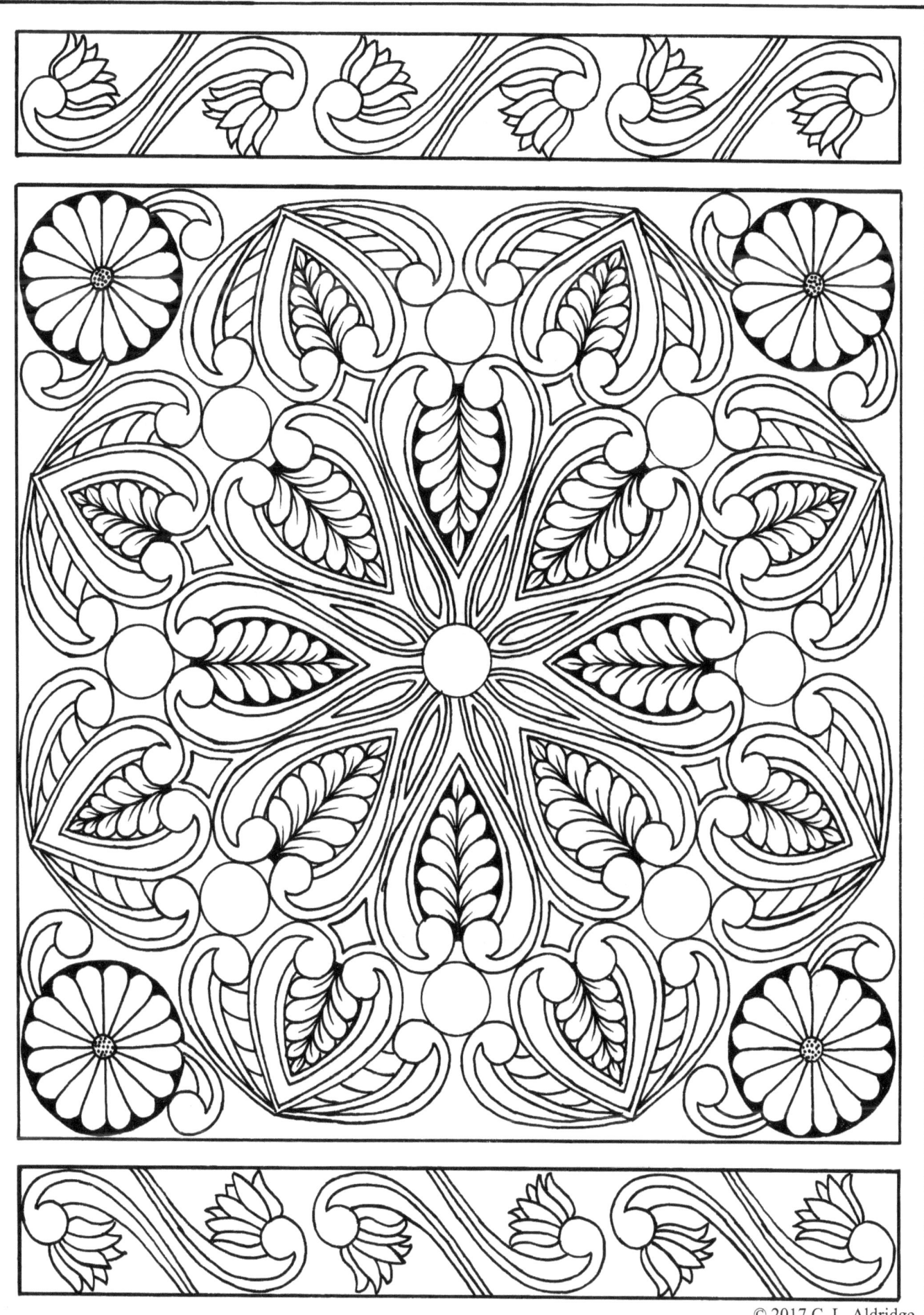

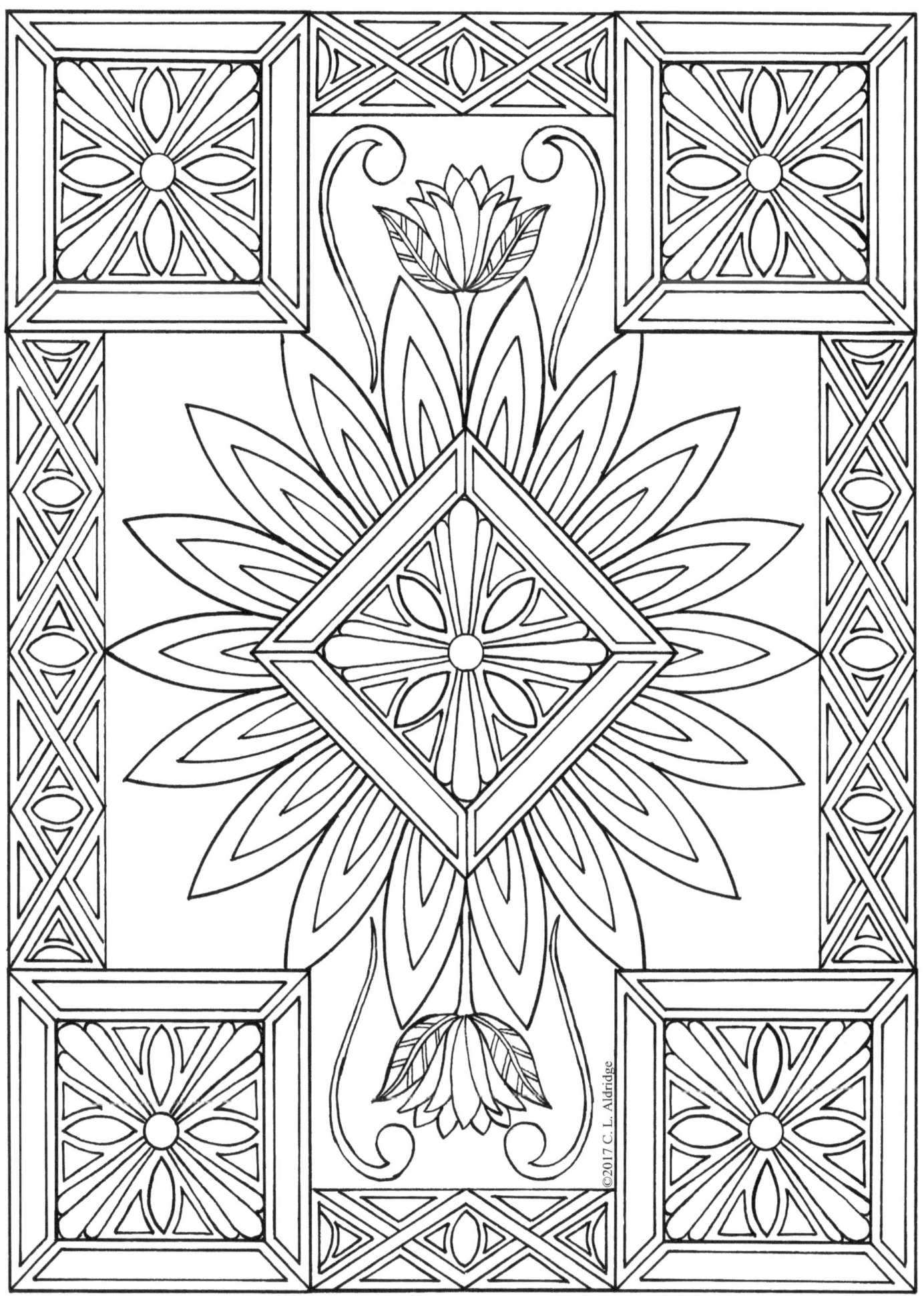

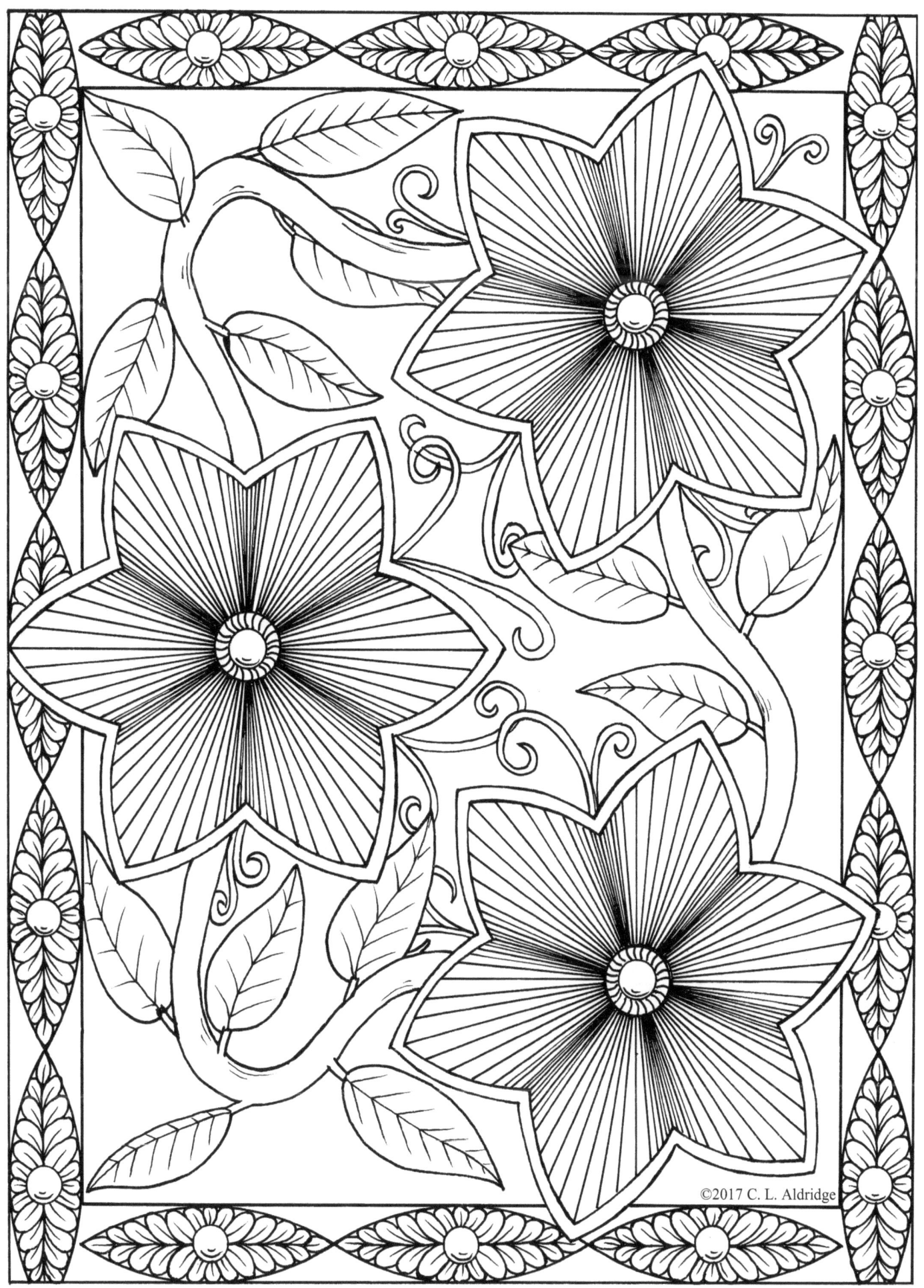

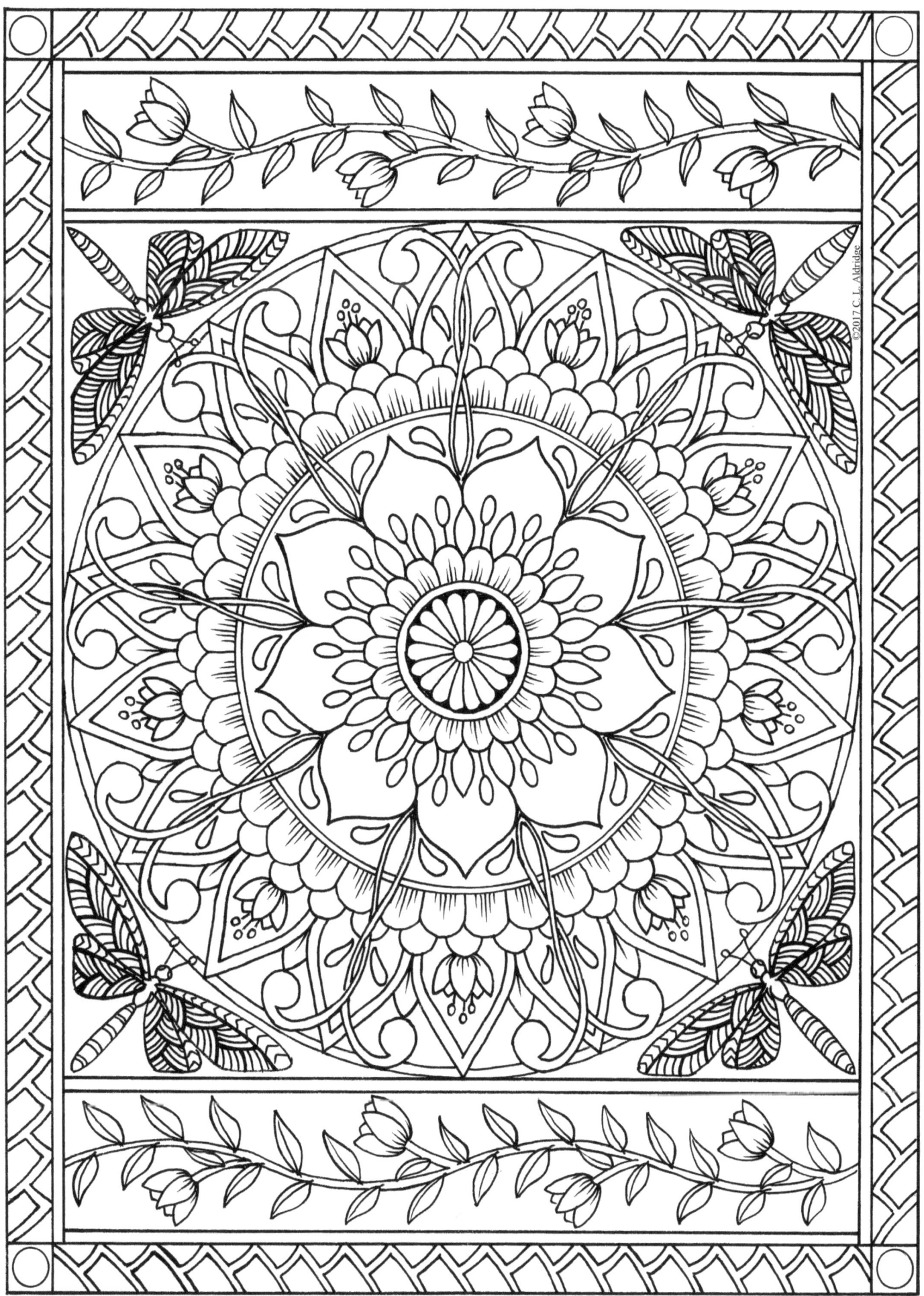

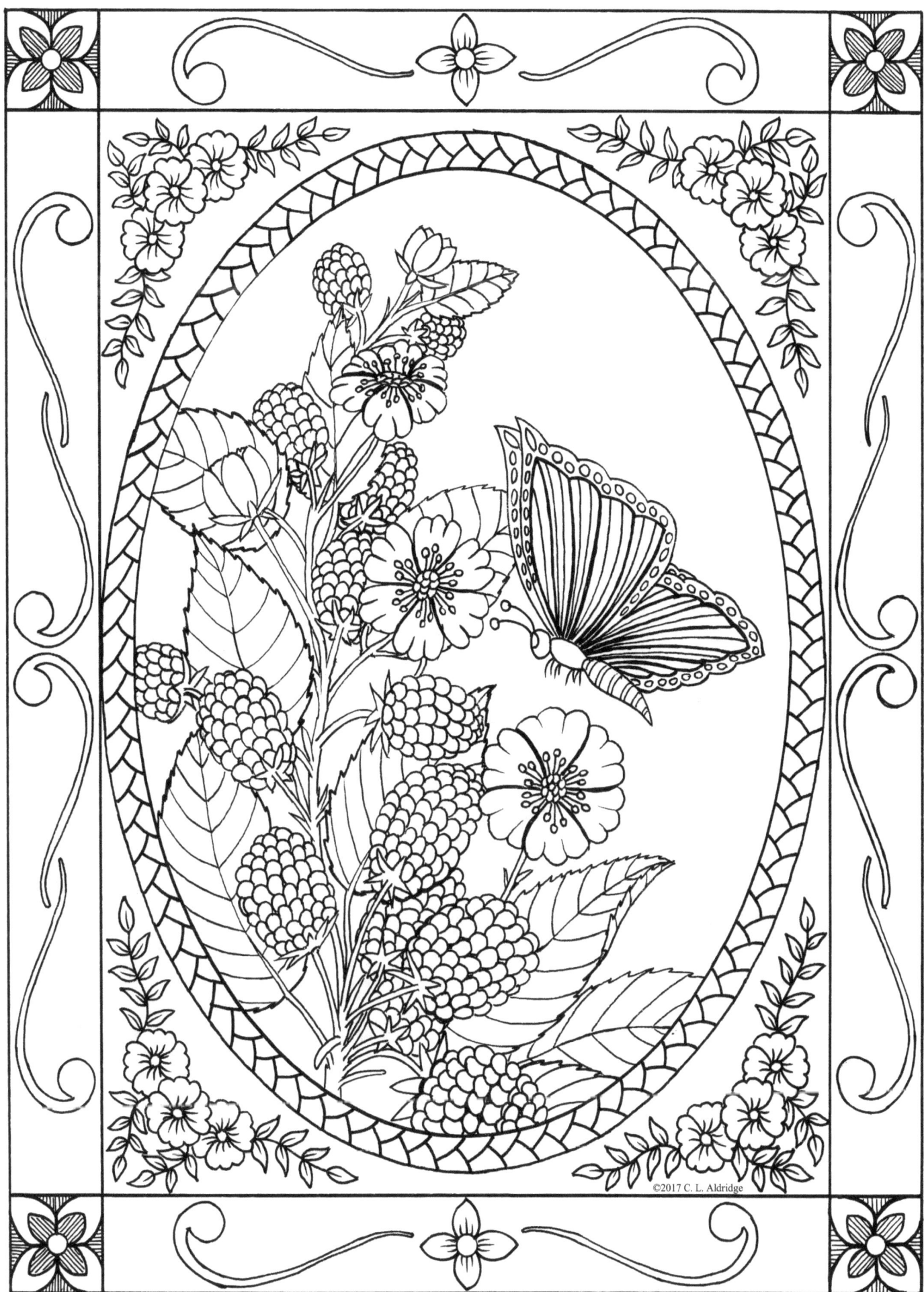

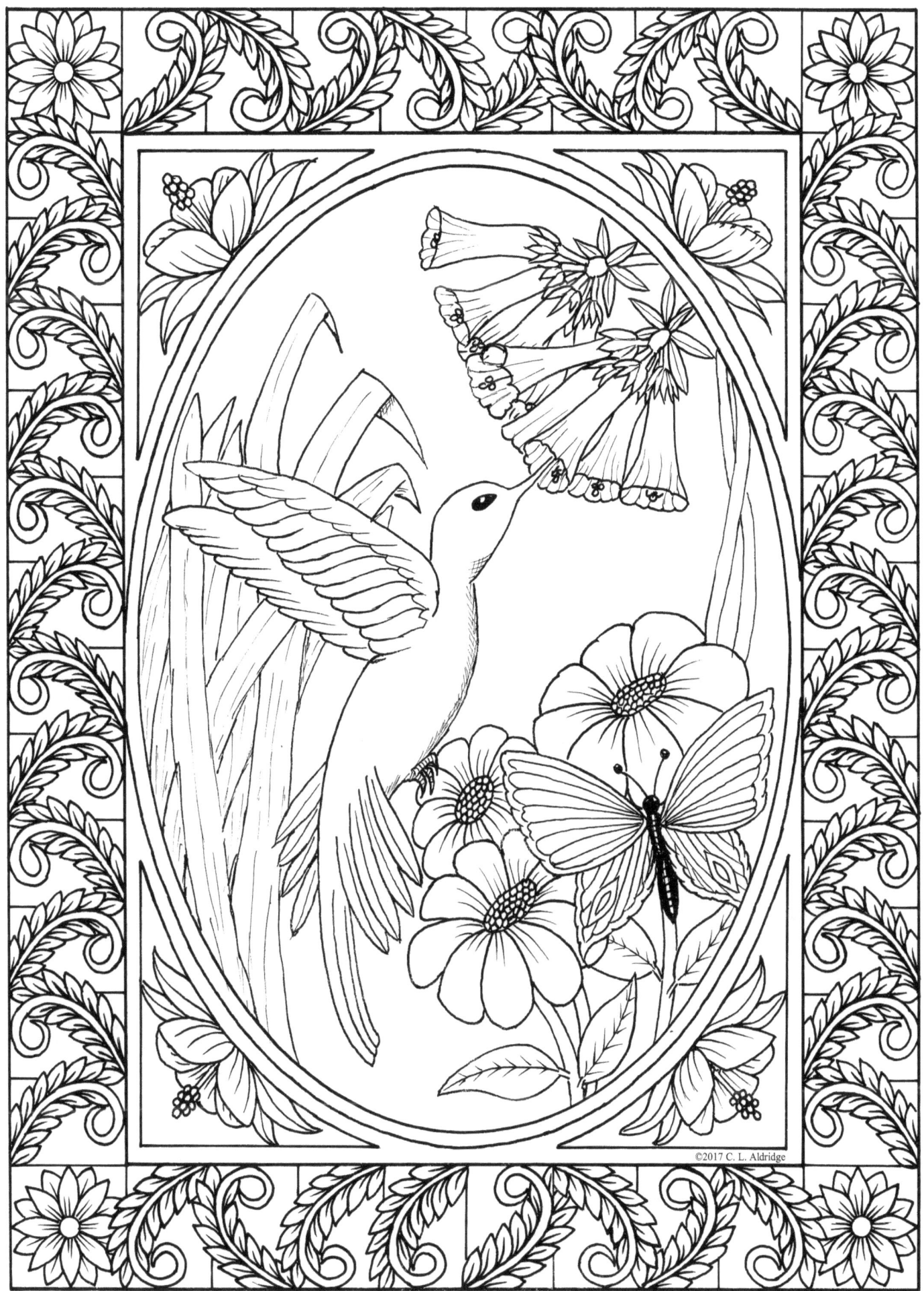

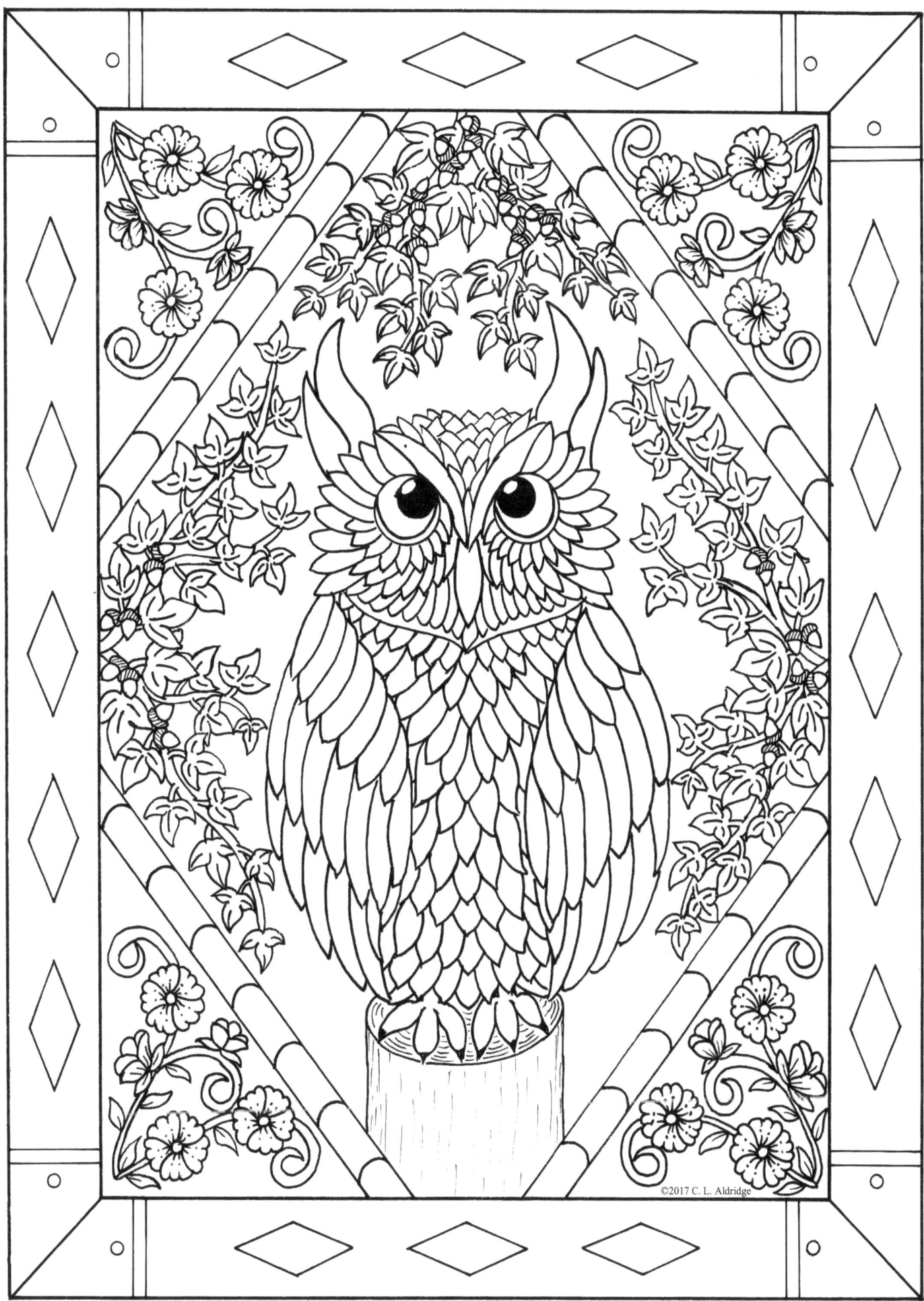

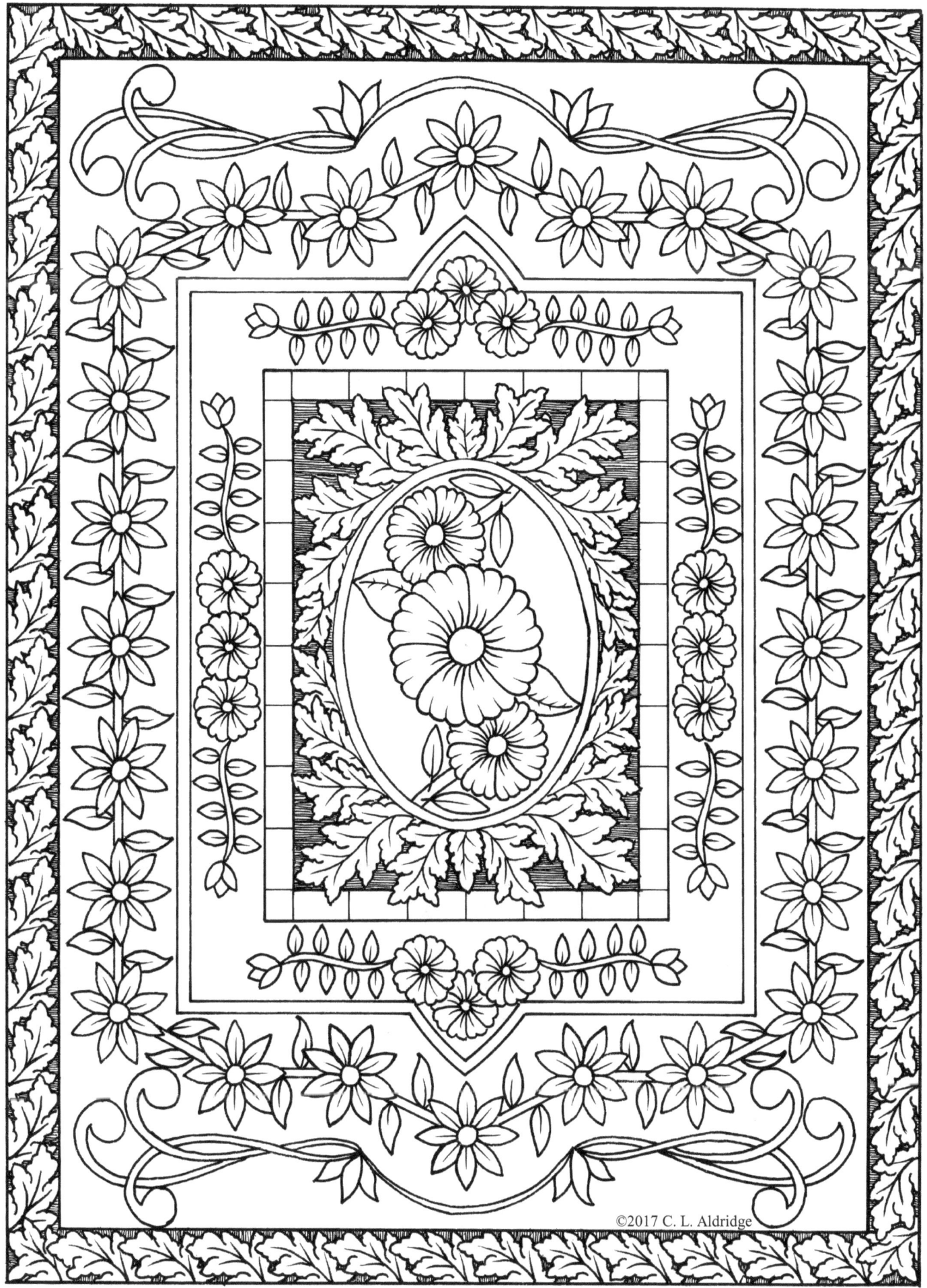

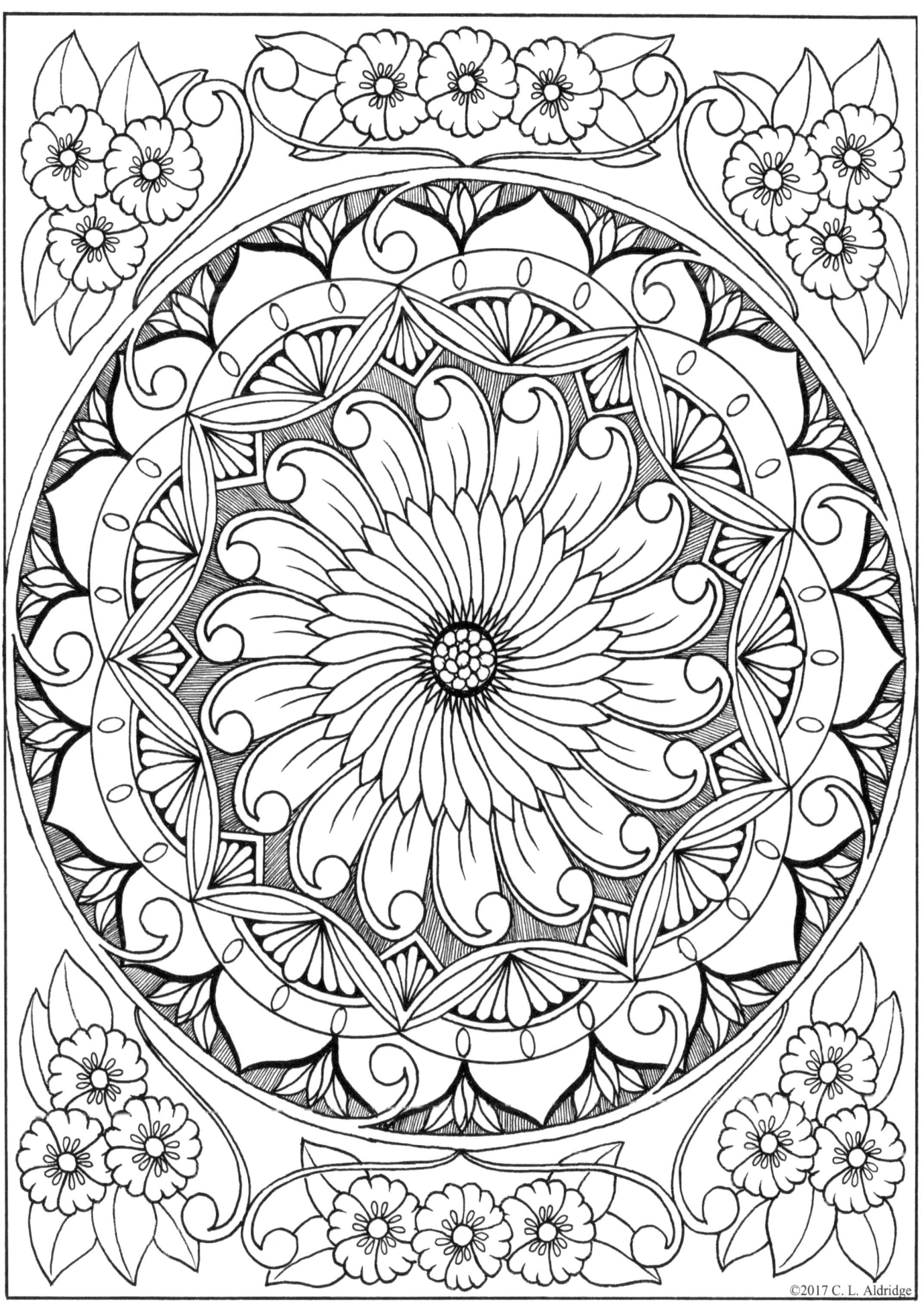

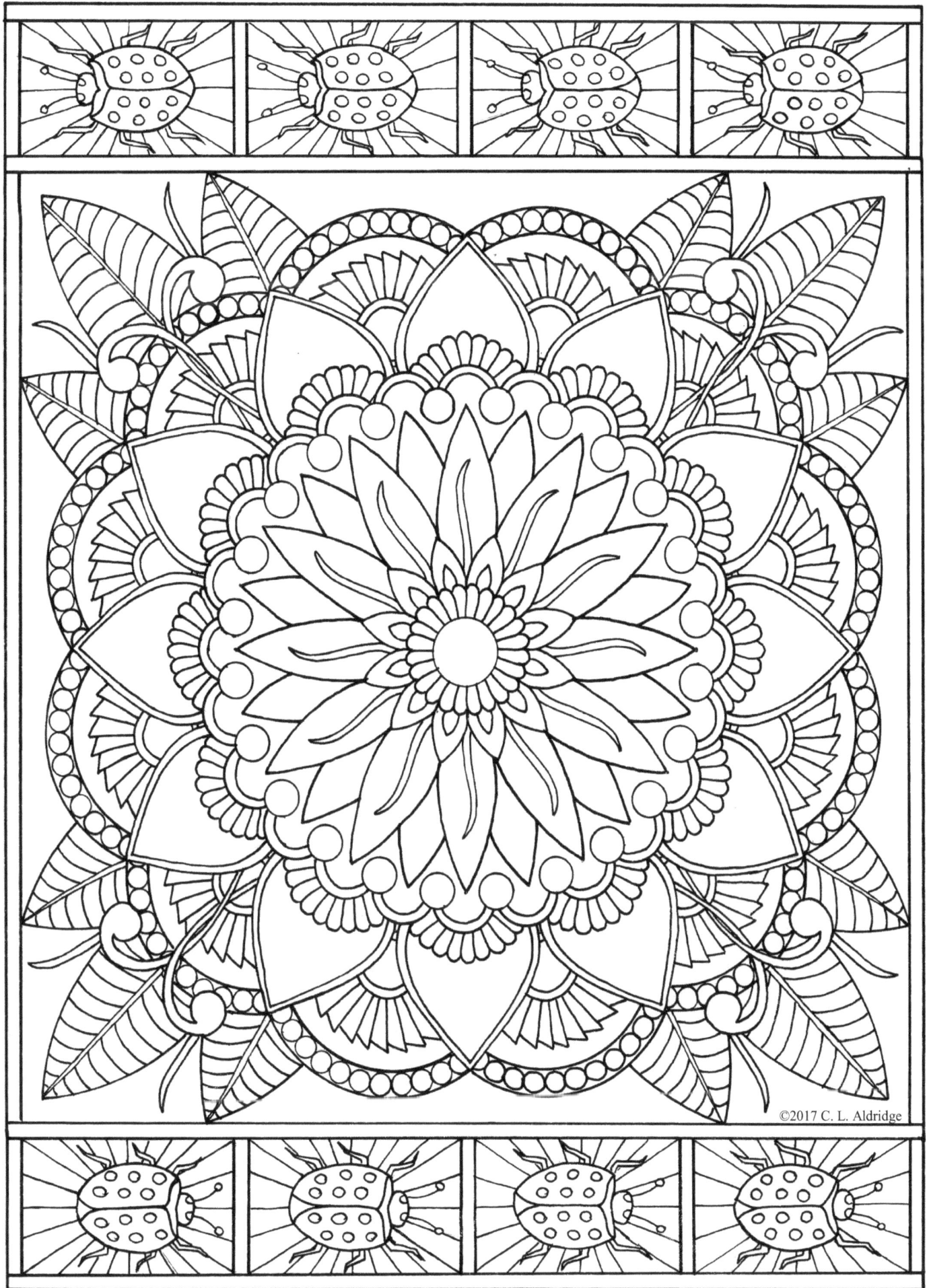

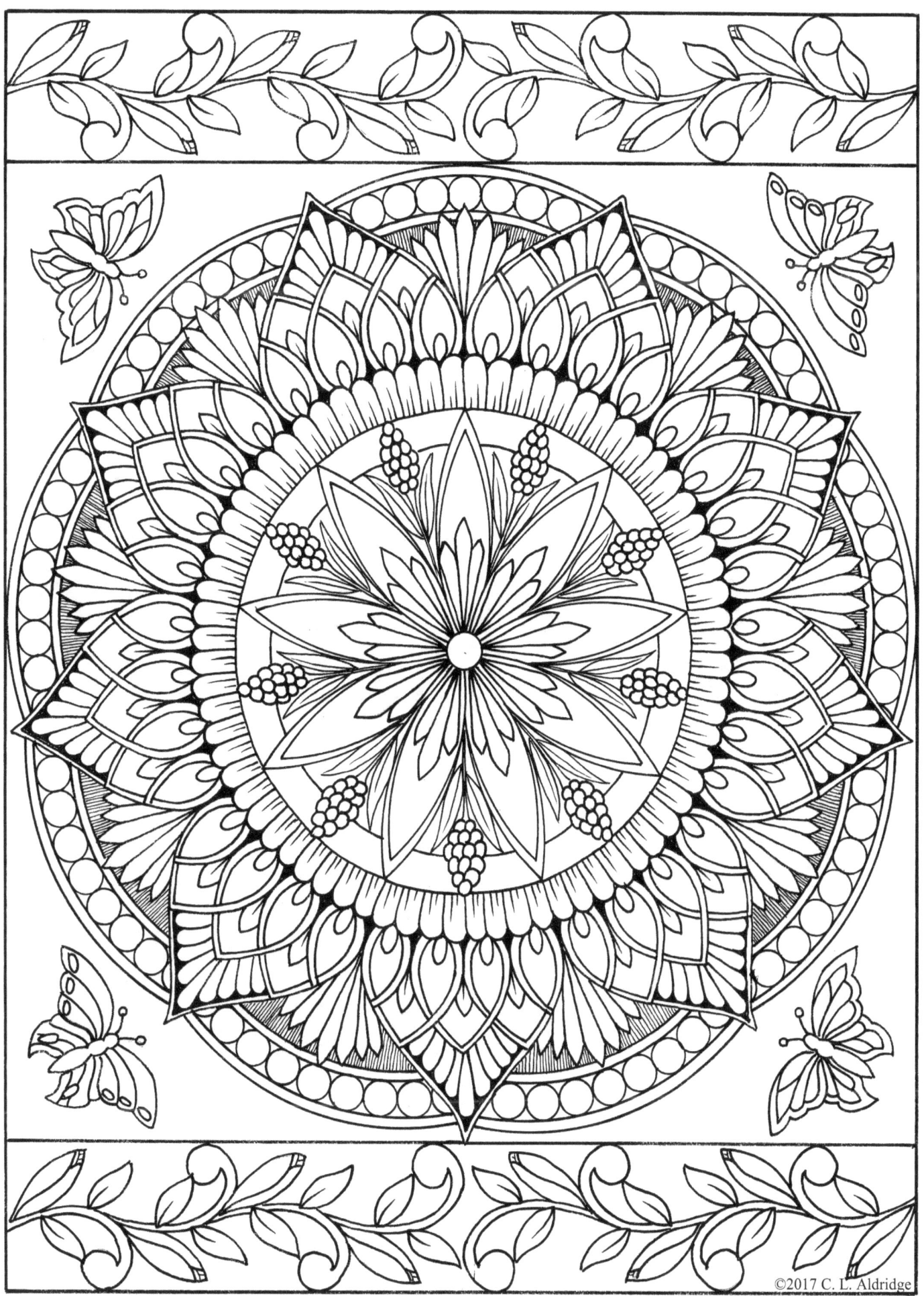

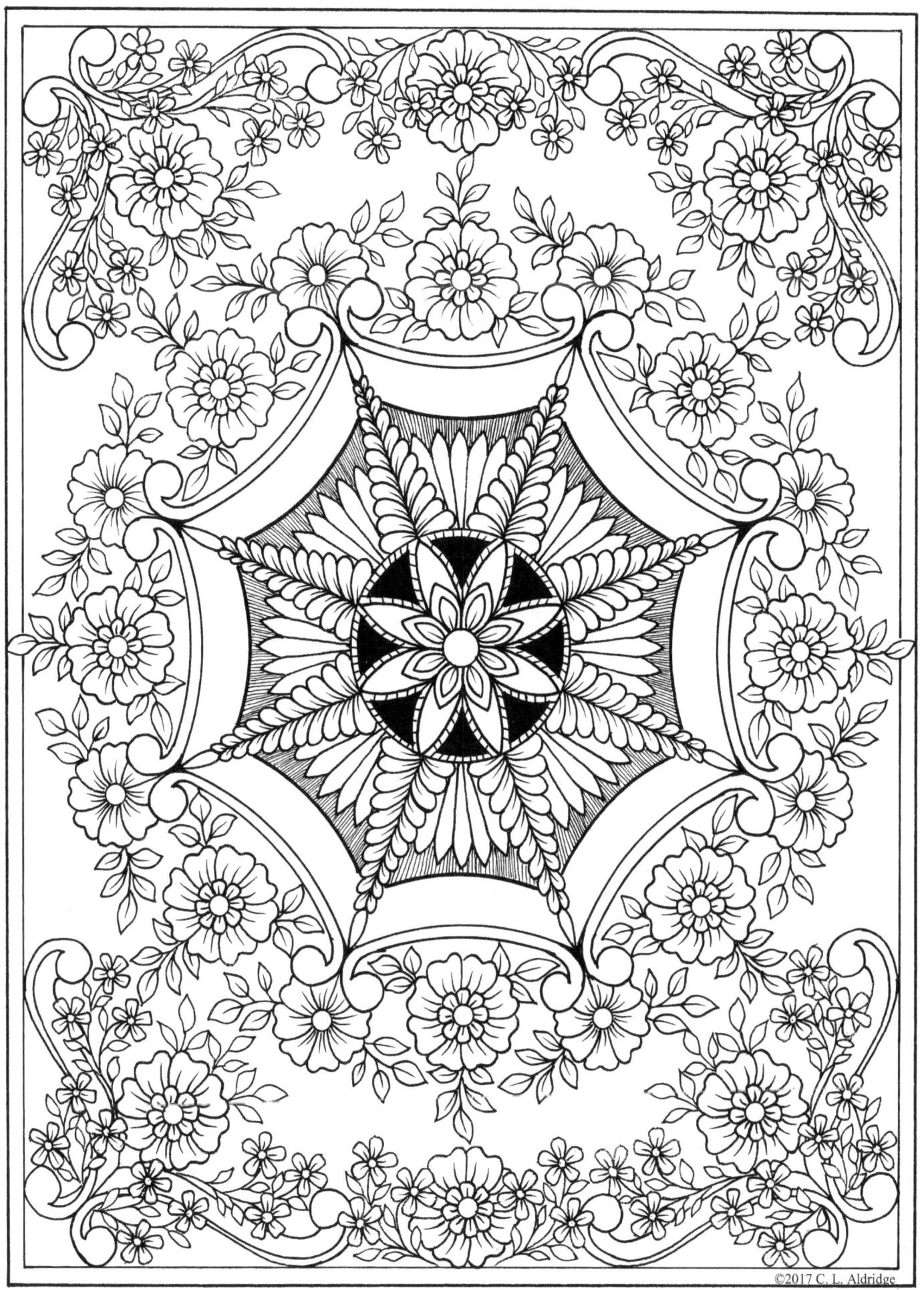

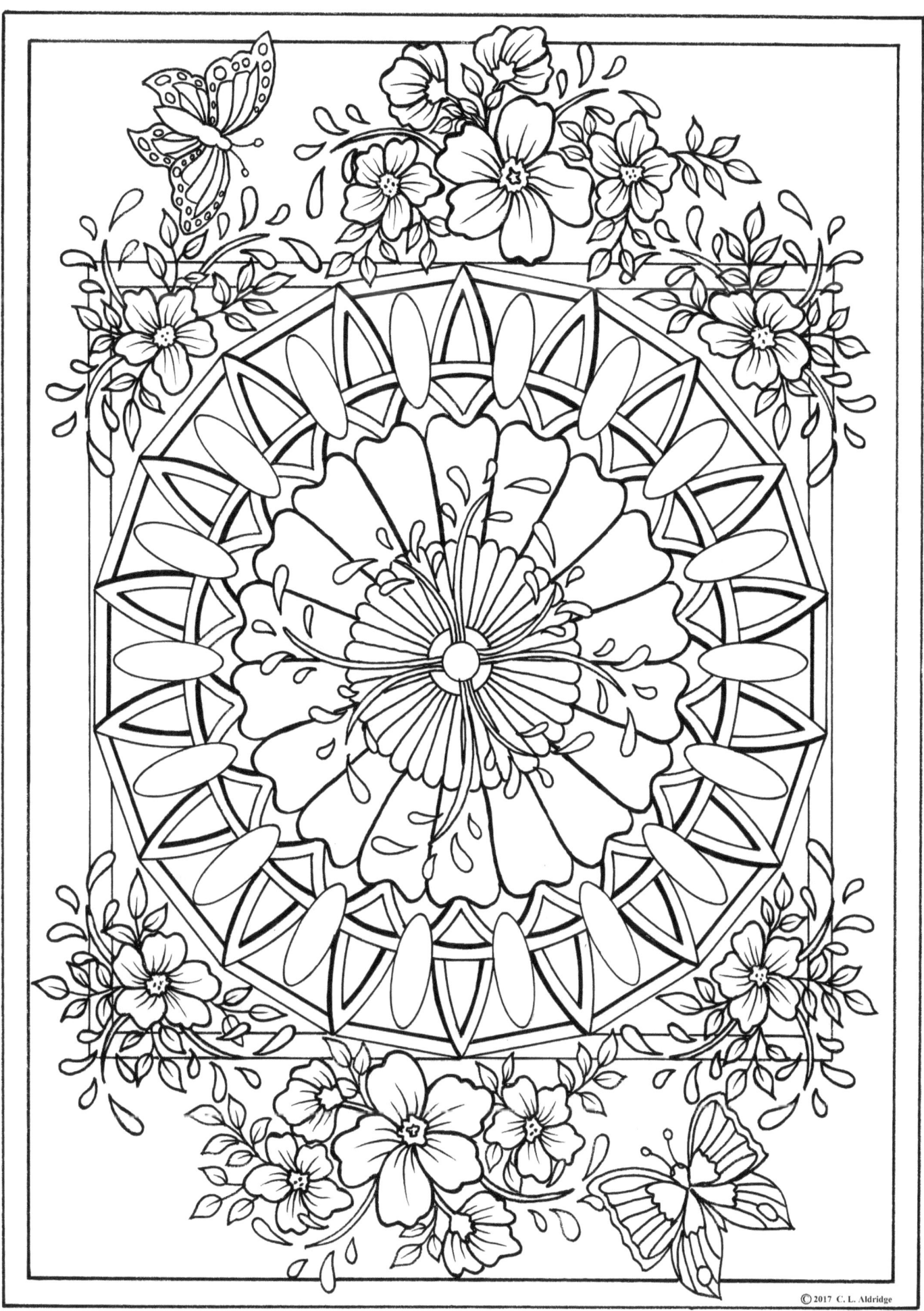

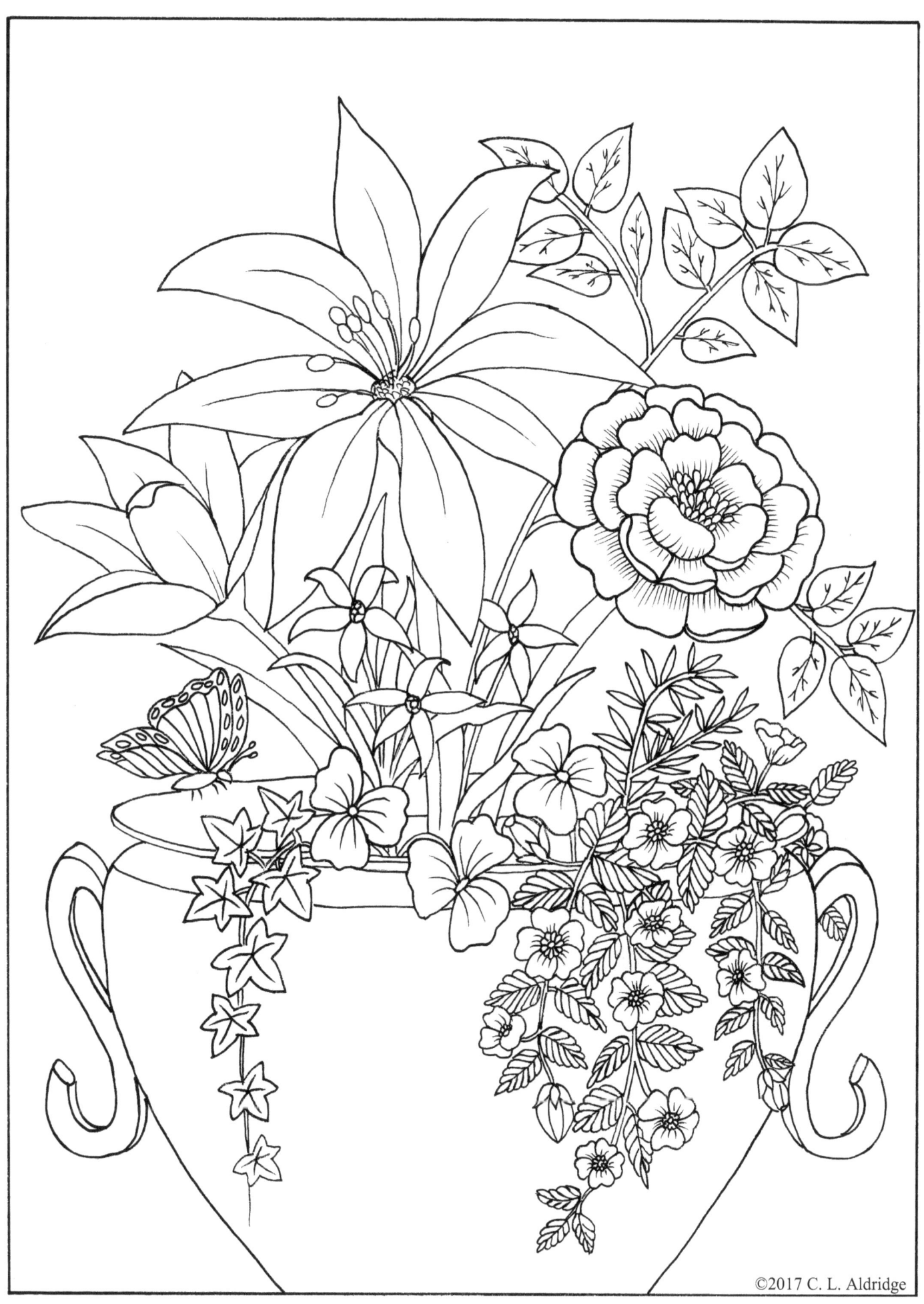

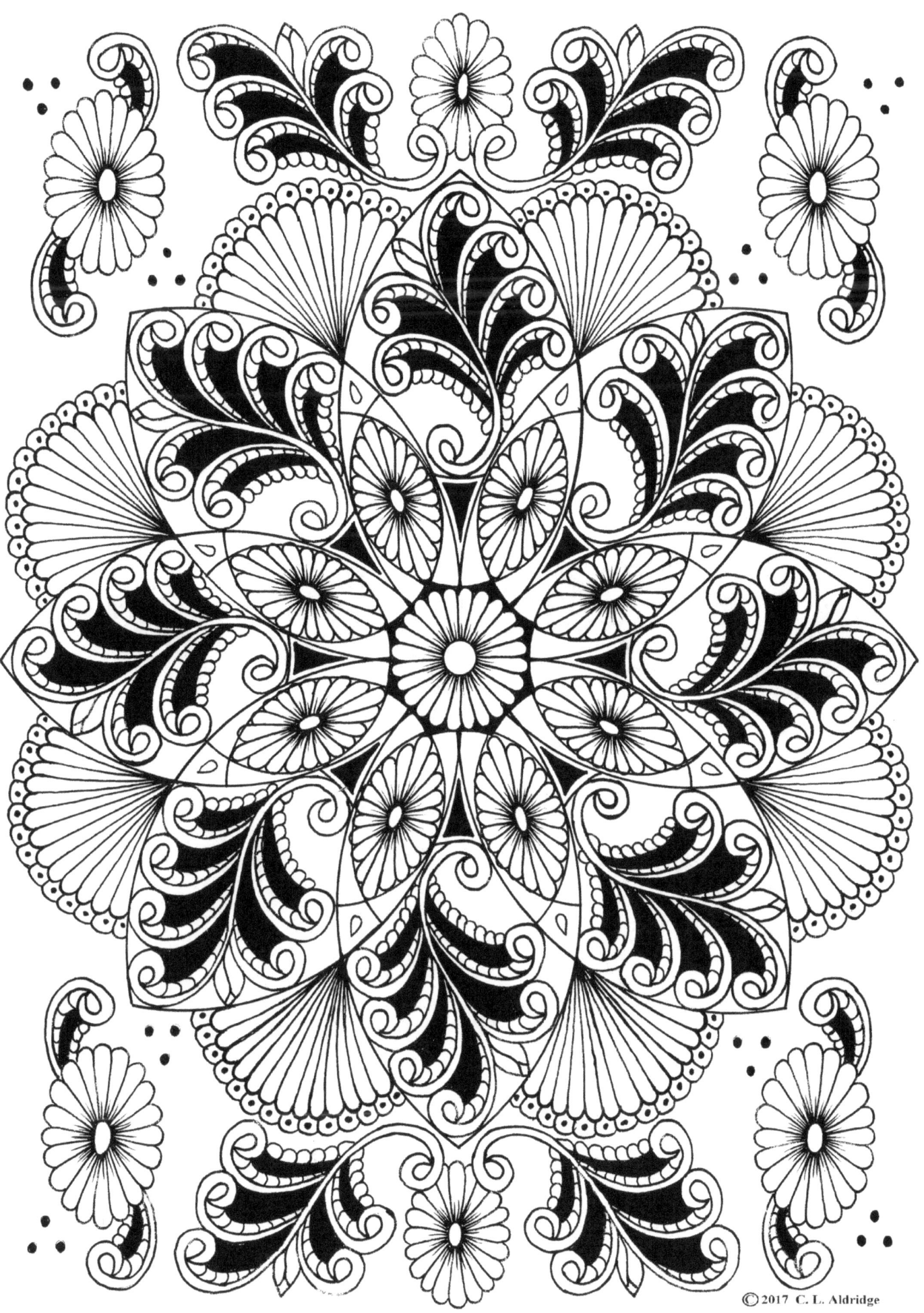

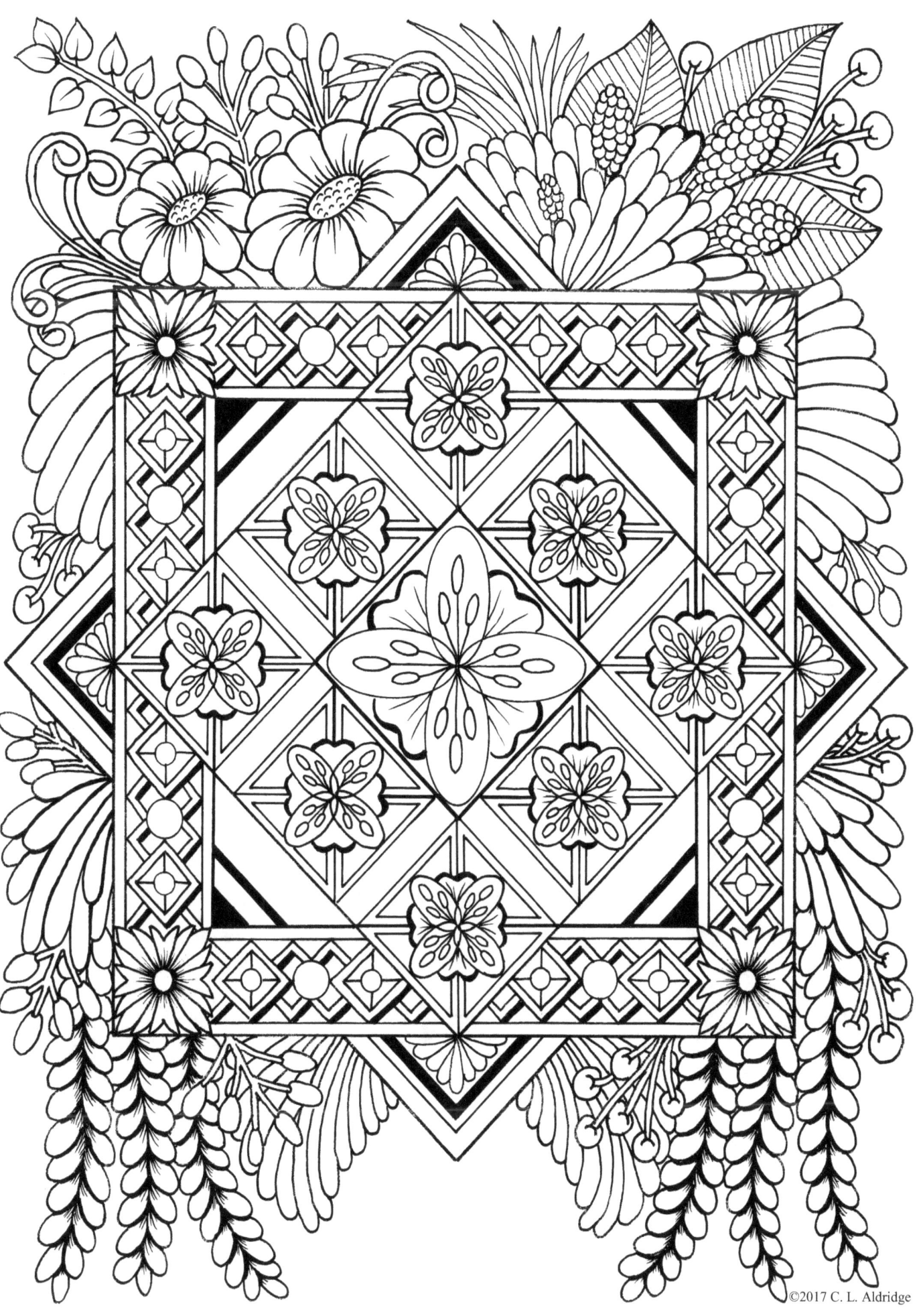

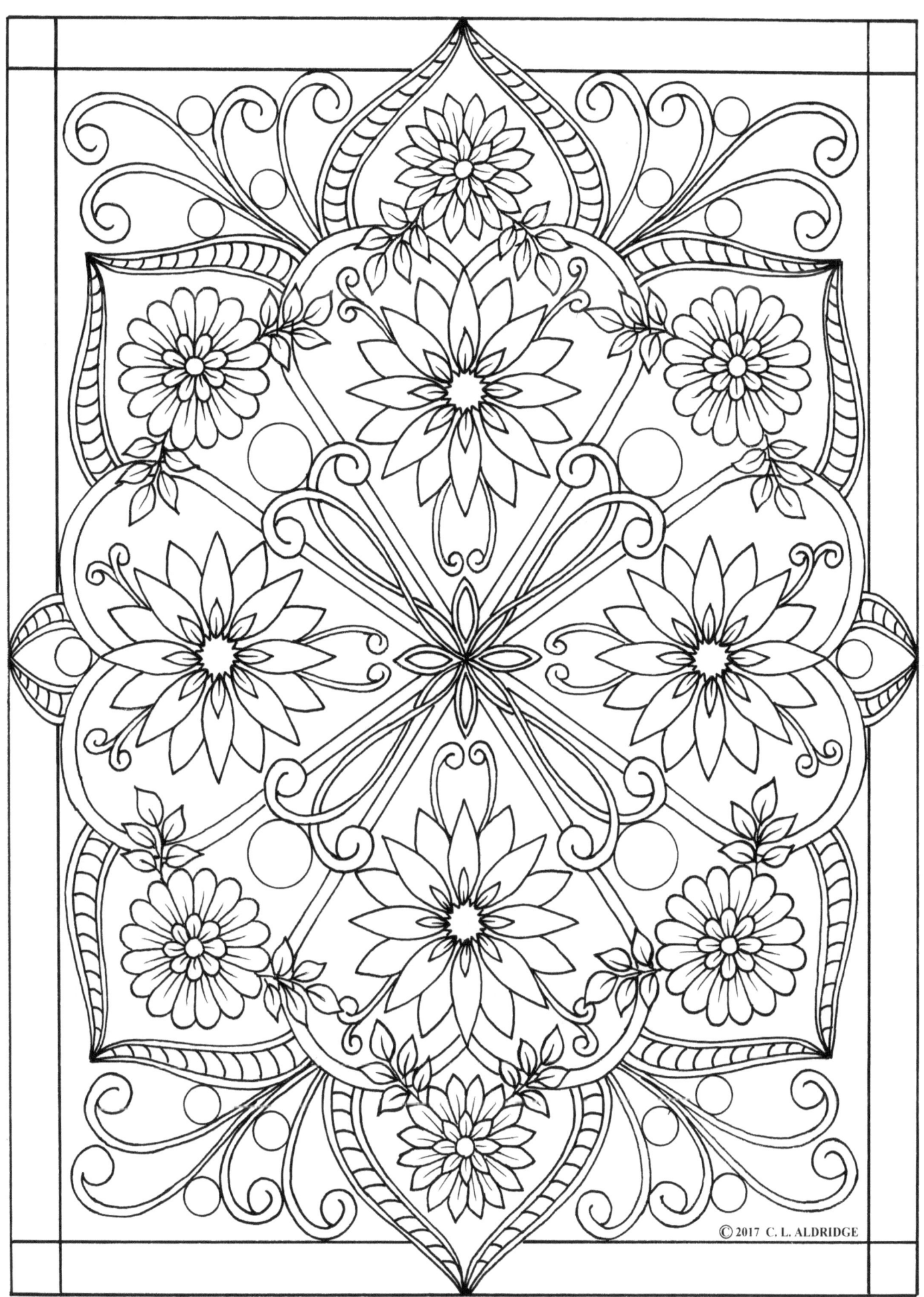

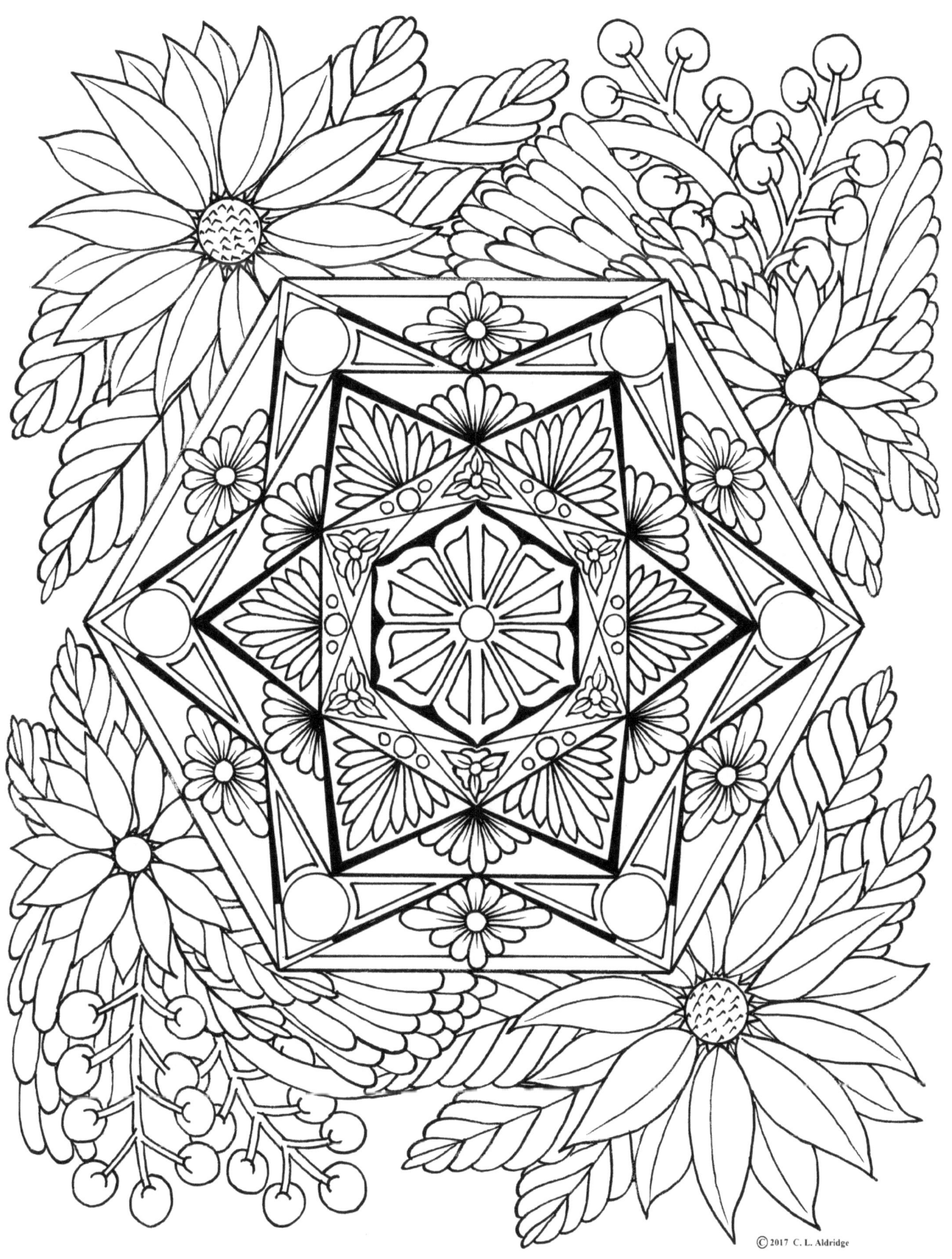

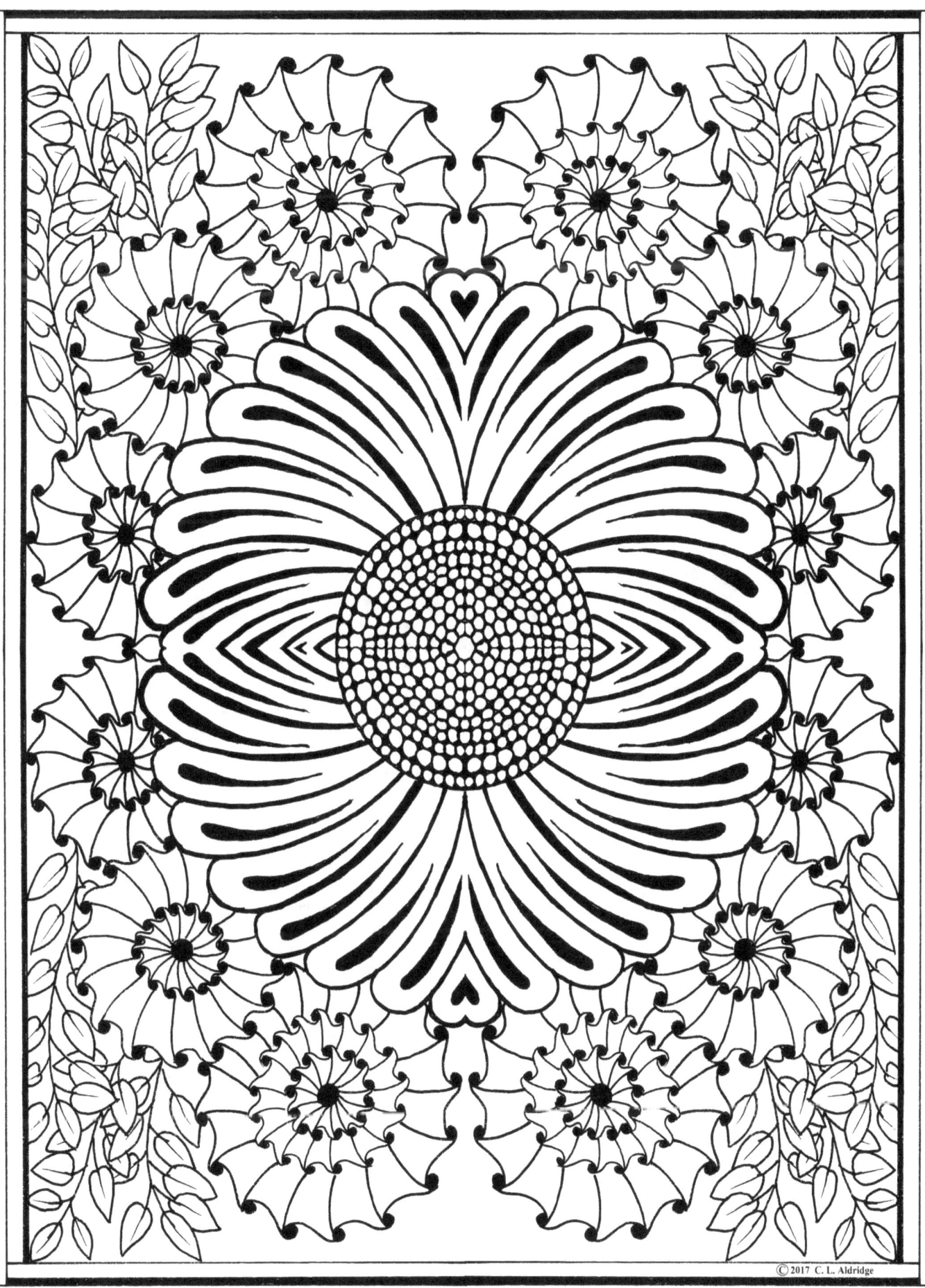

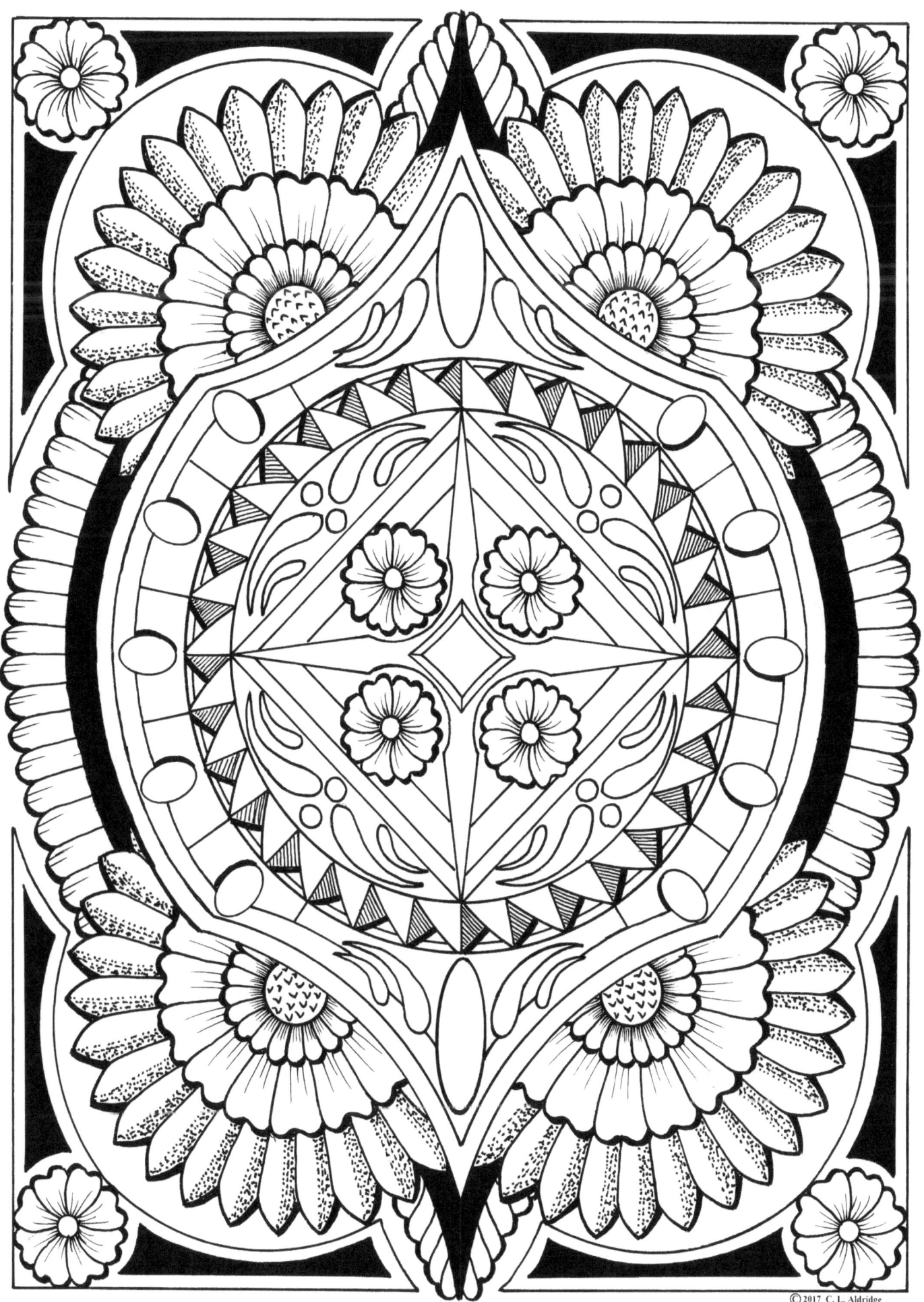

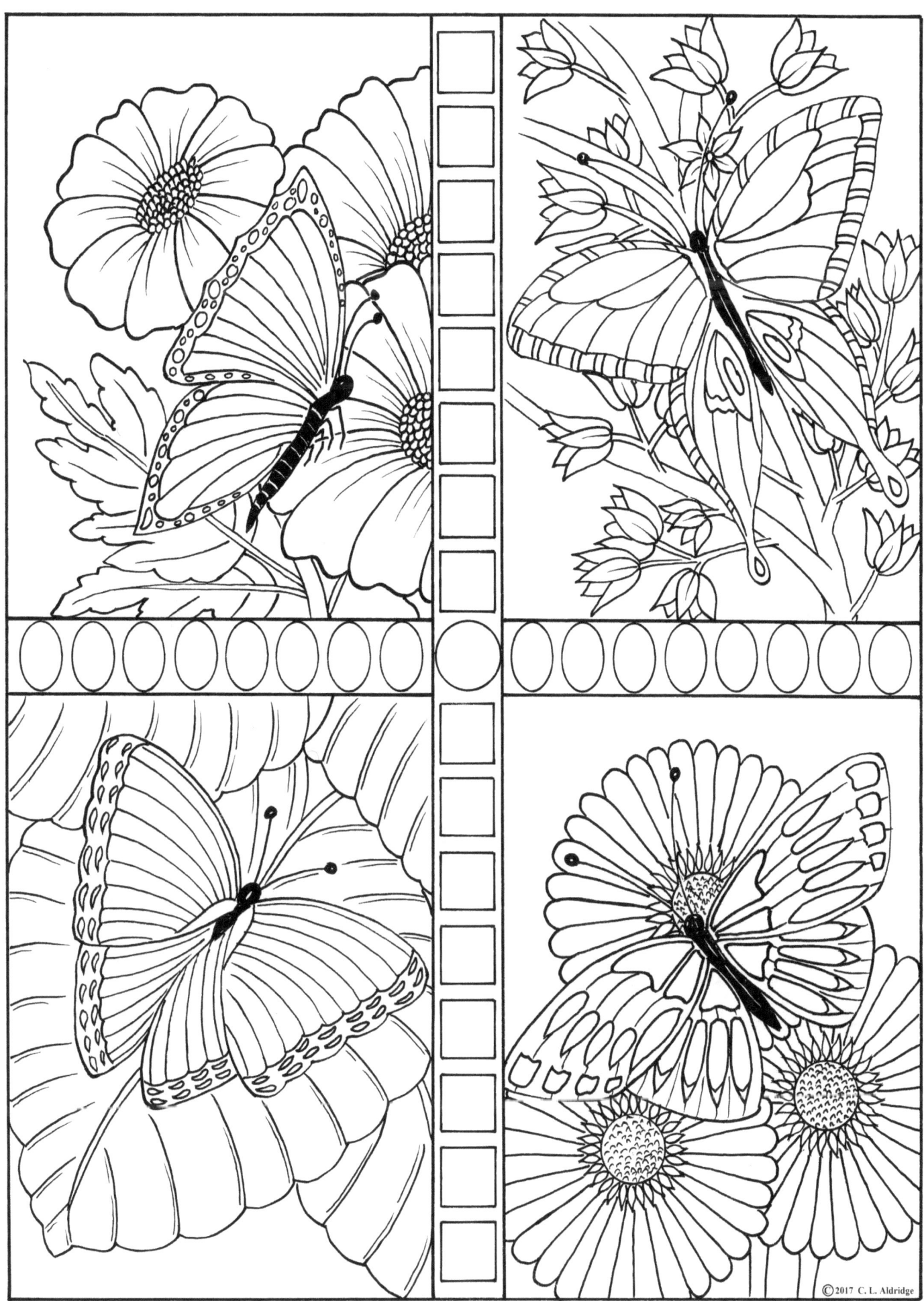

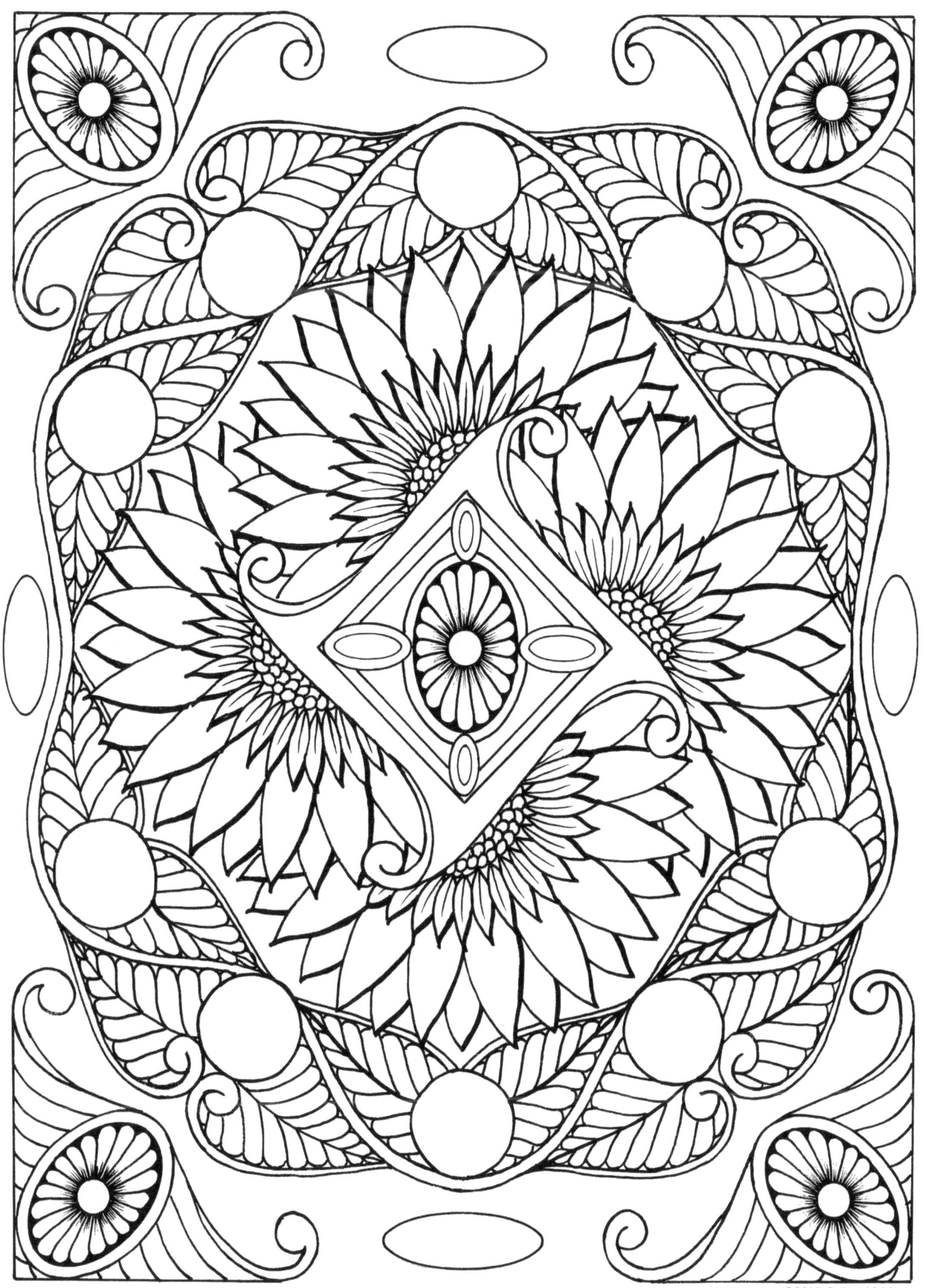

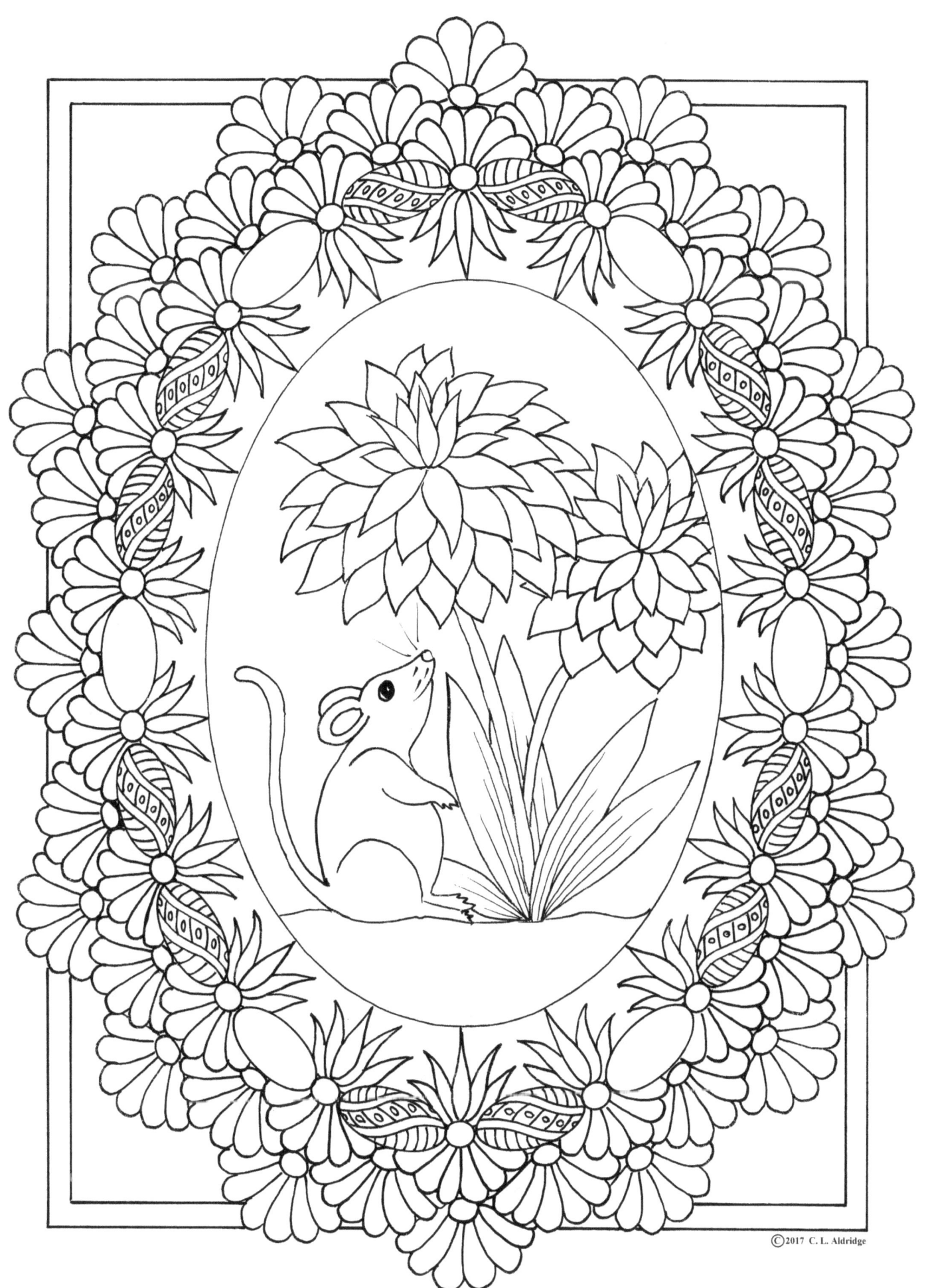

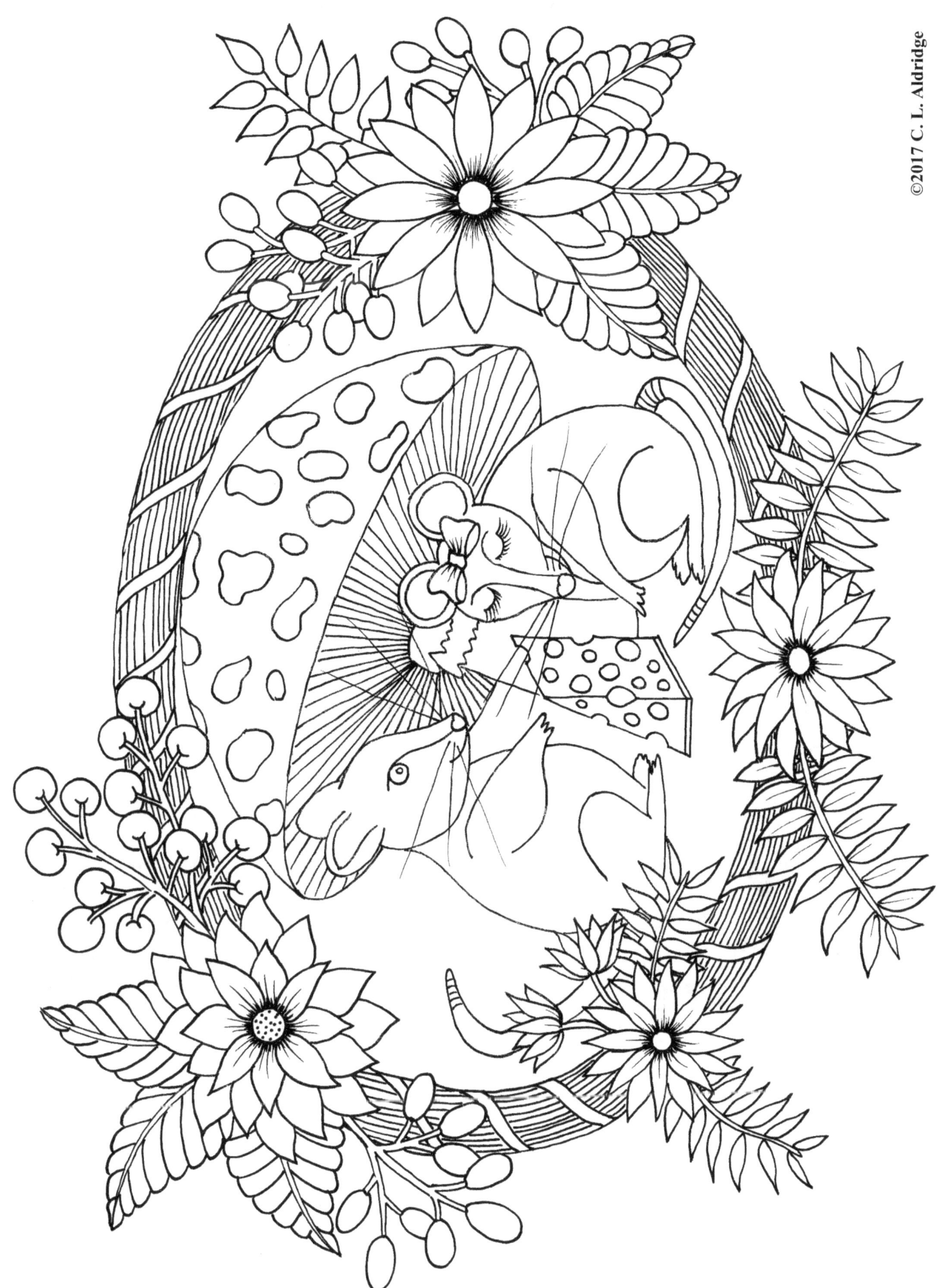

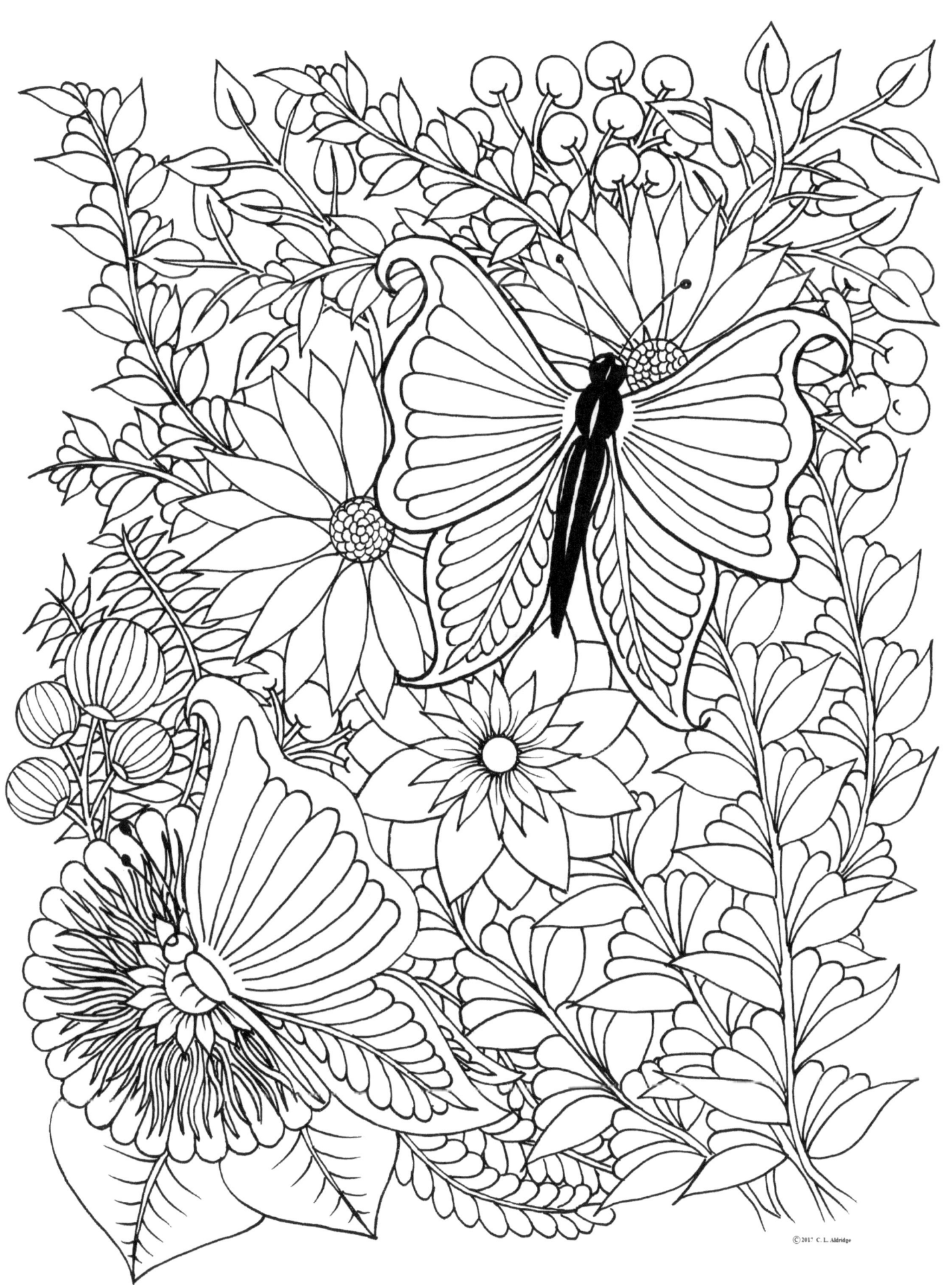

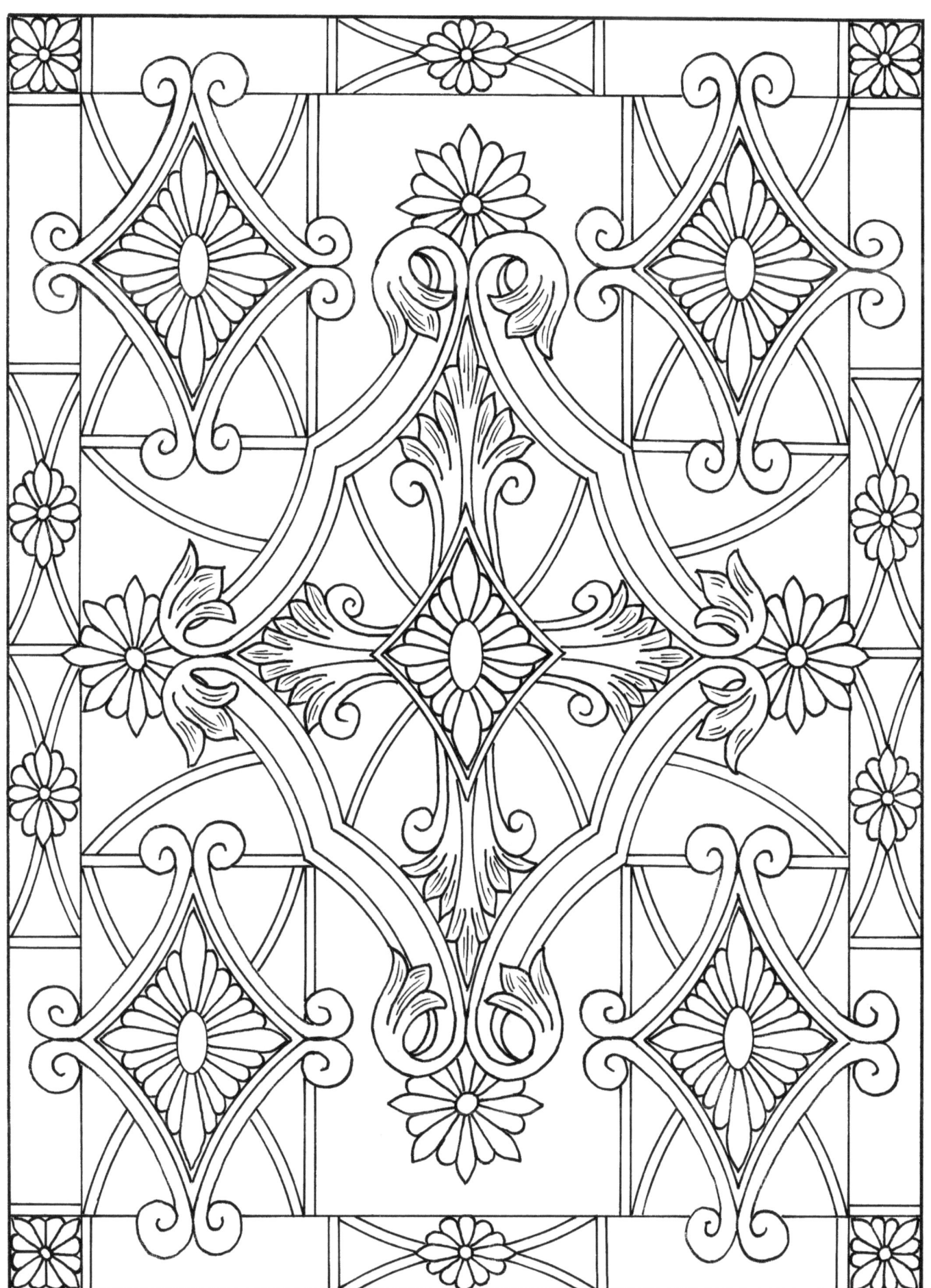

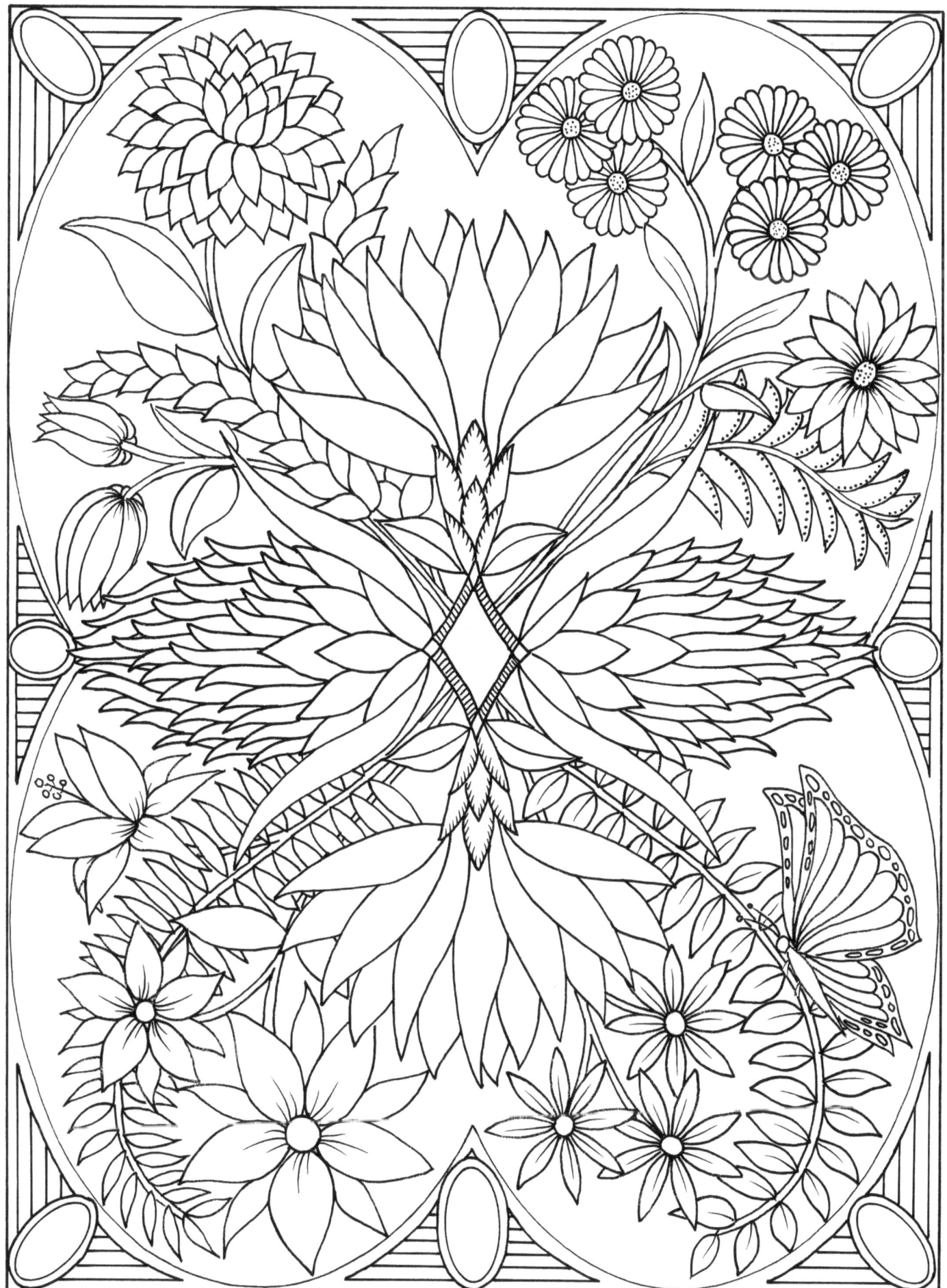

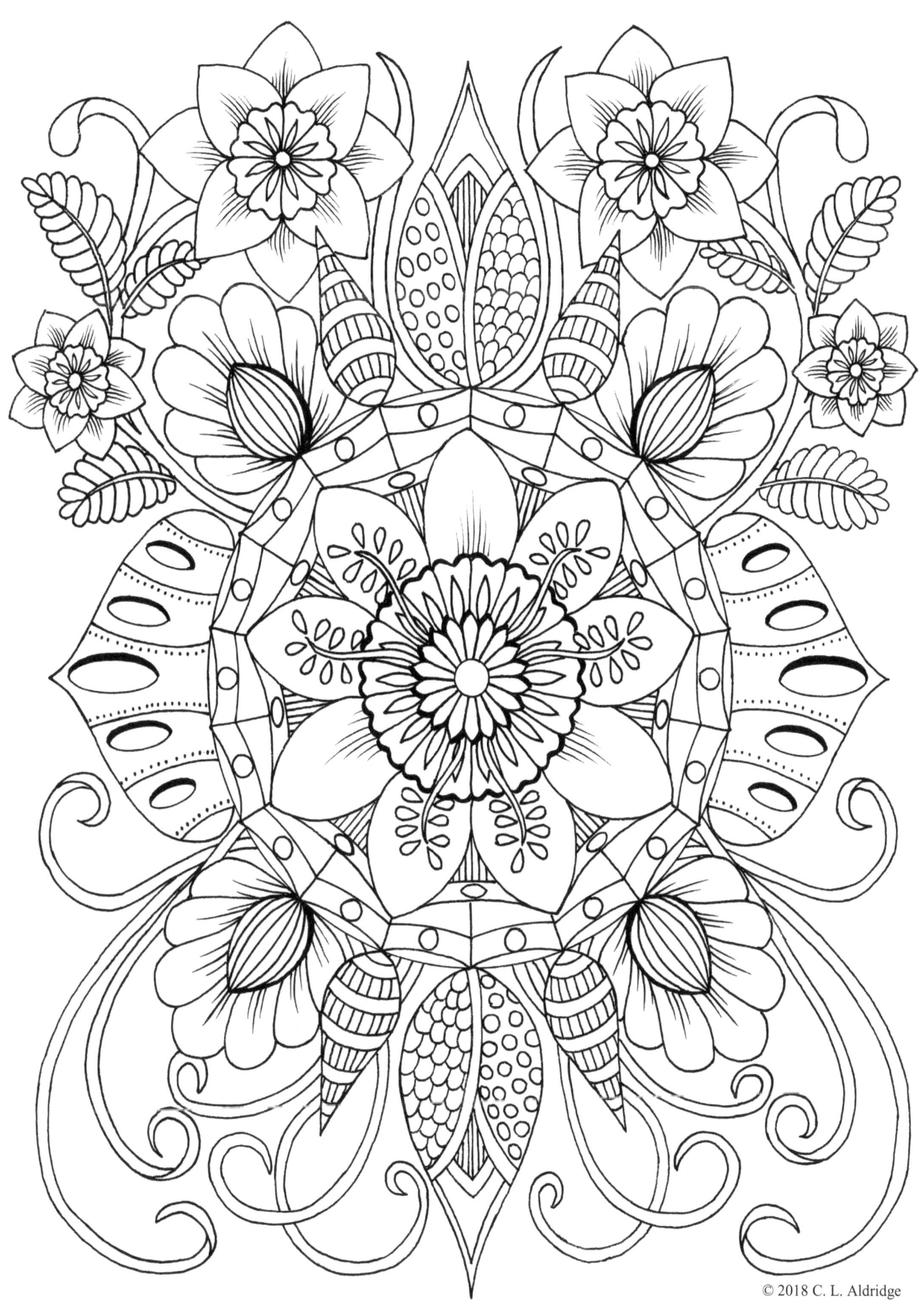

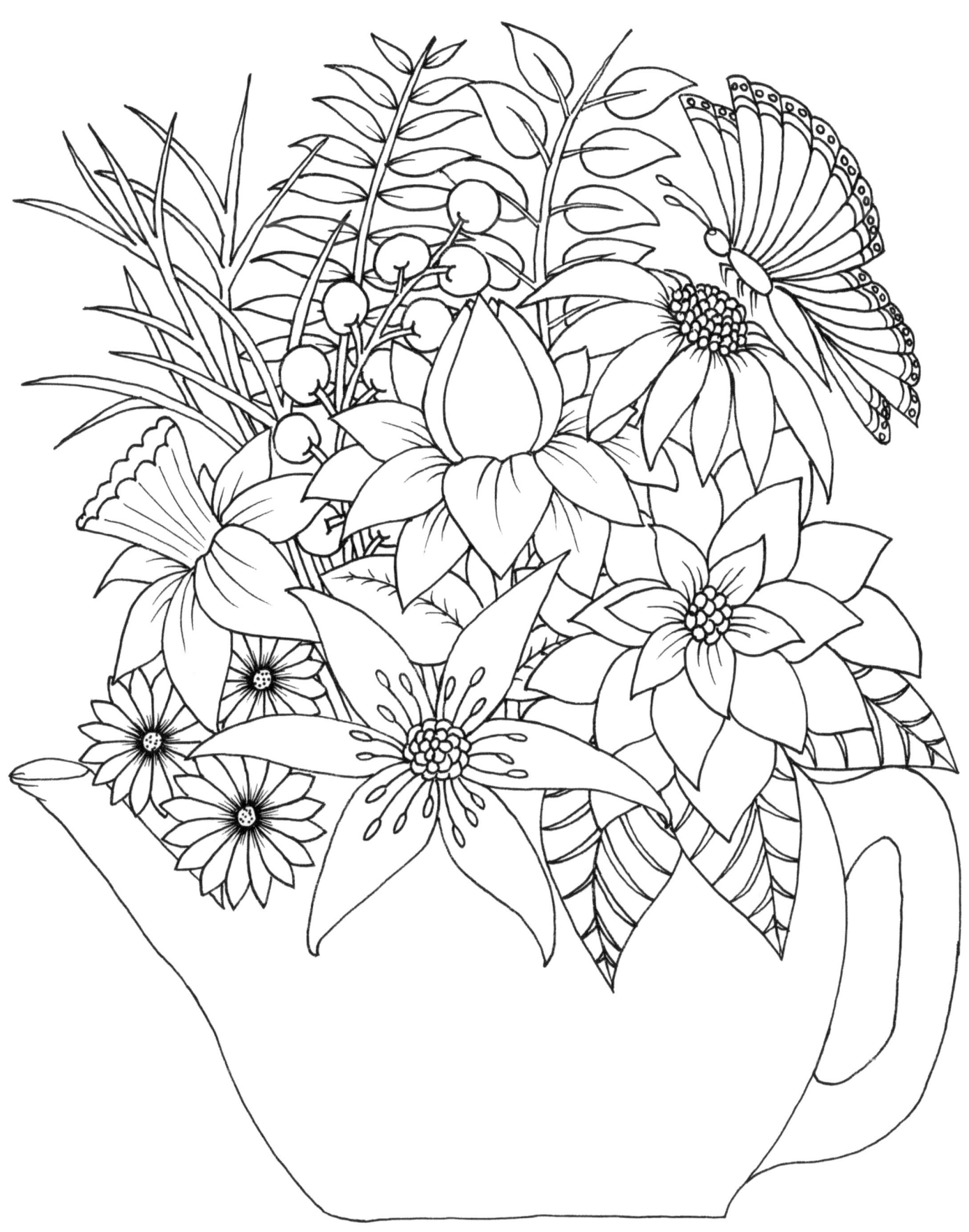

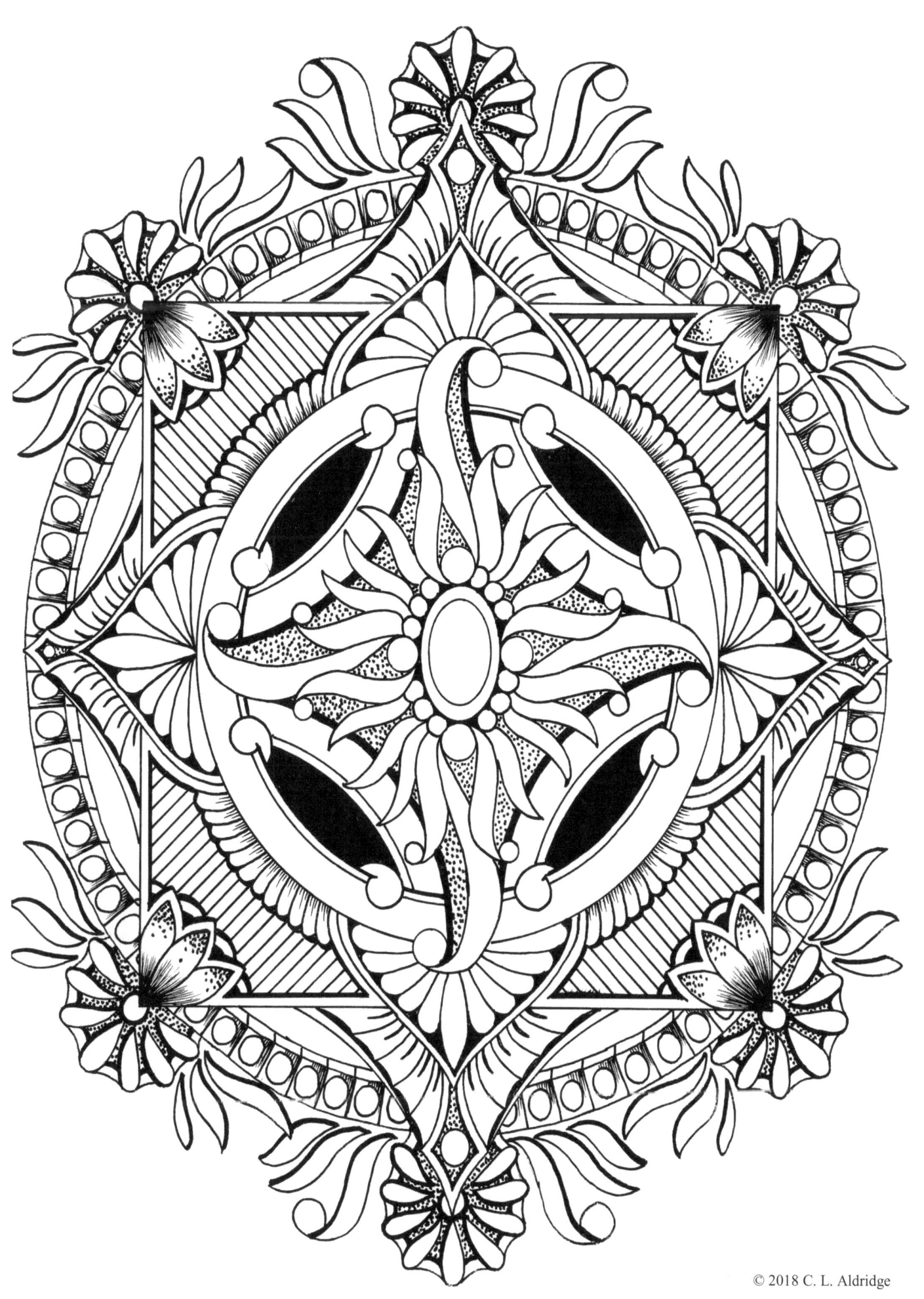

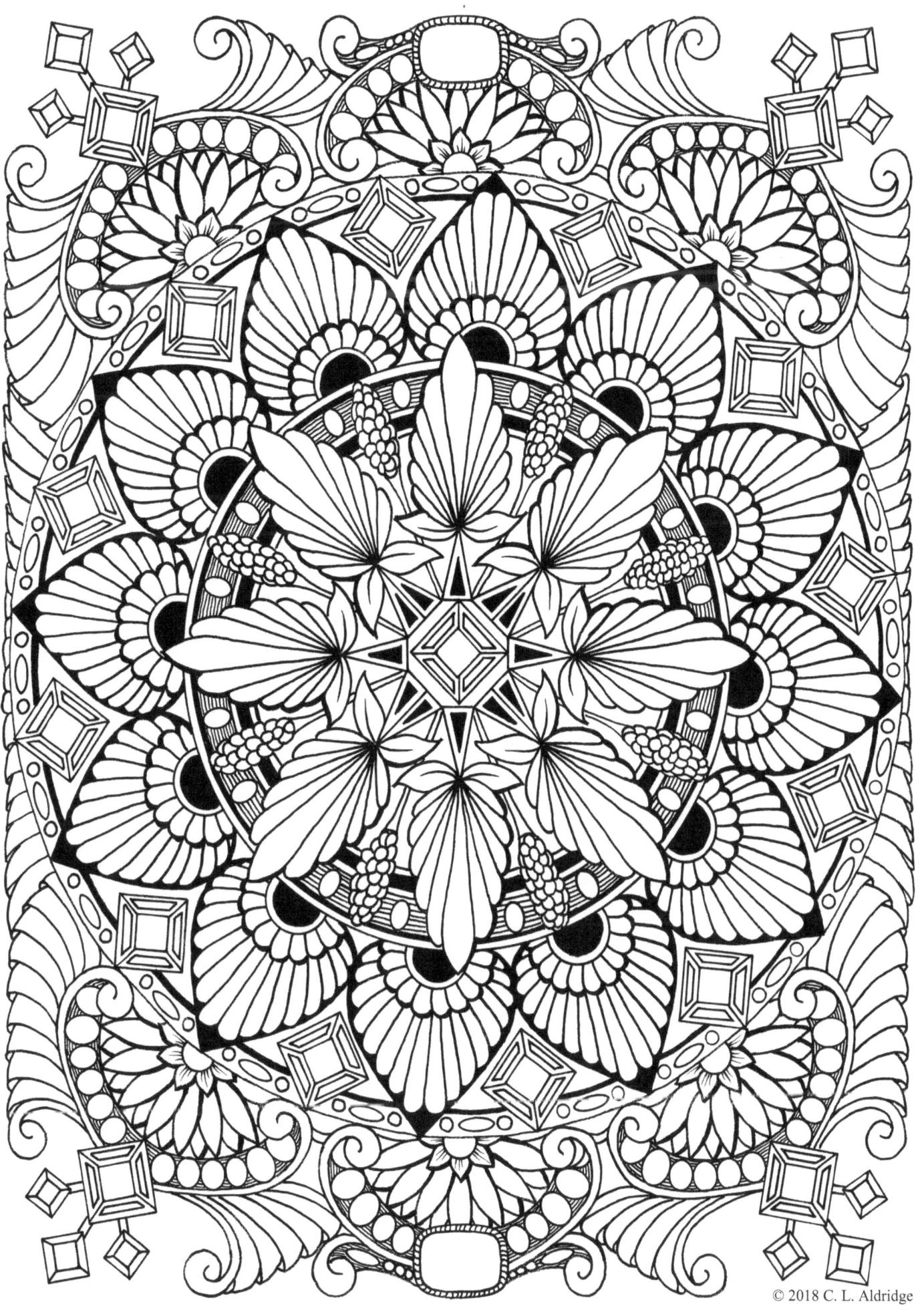

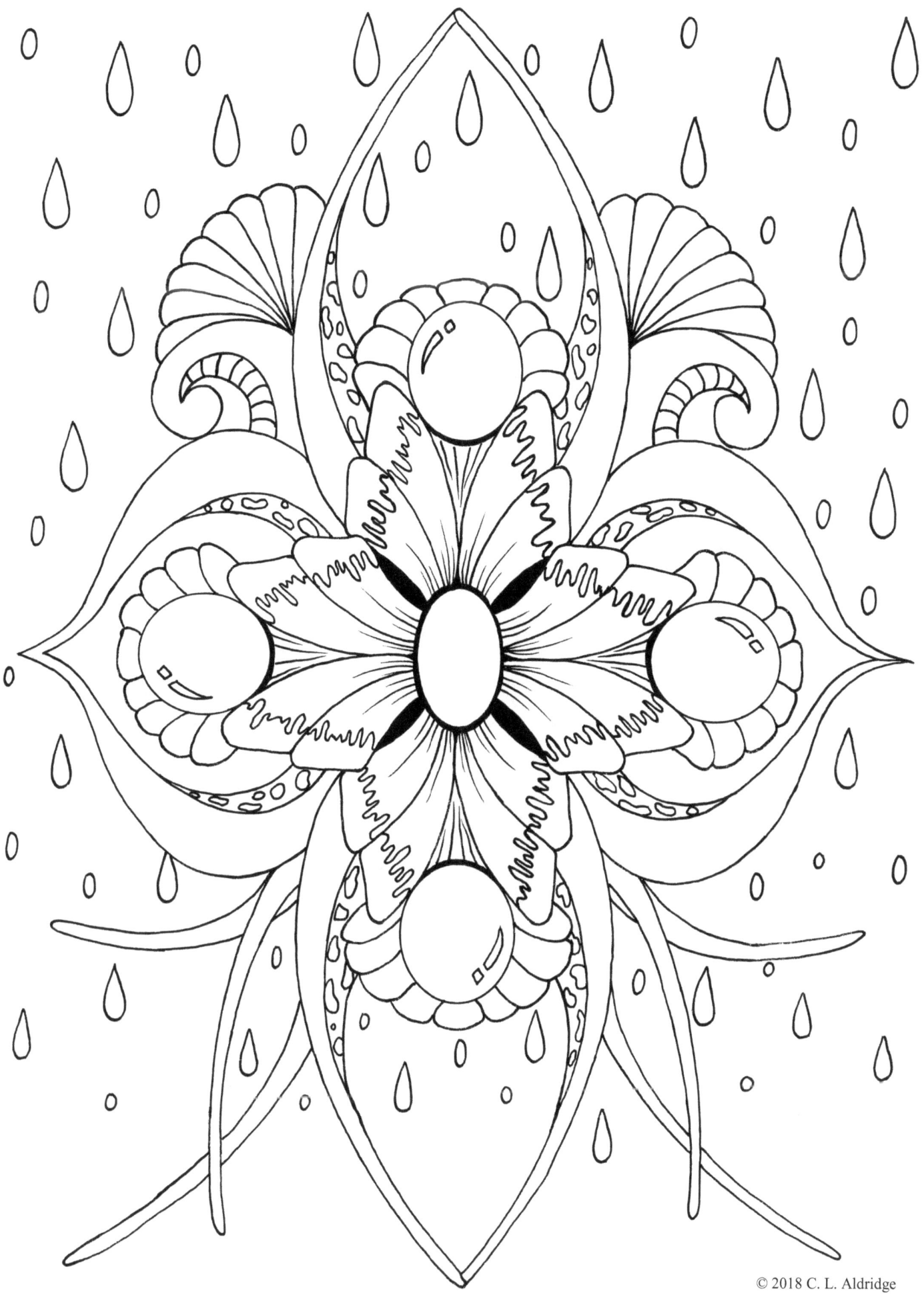

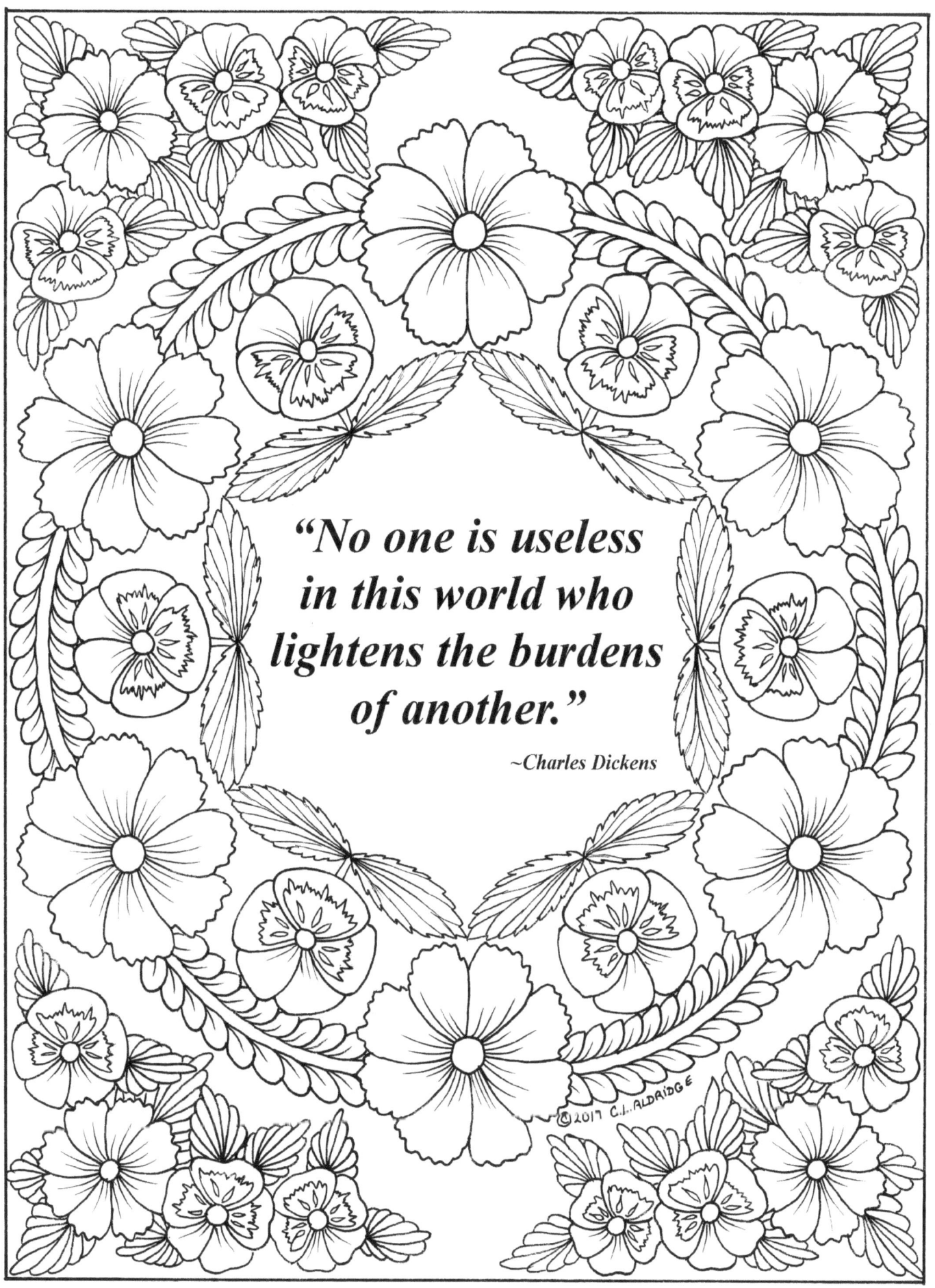

This page has intentionally been left blank for use as either a blotting page or color testing page.

This page has intentionally been left blank for use as either a blotting page or color testing page.

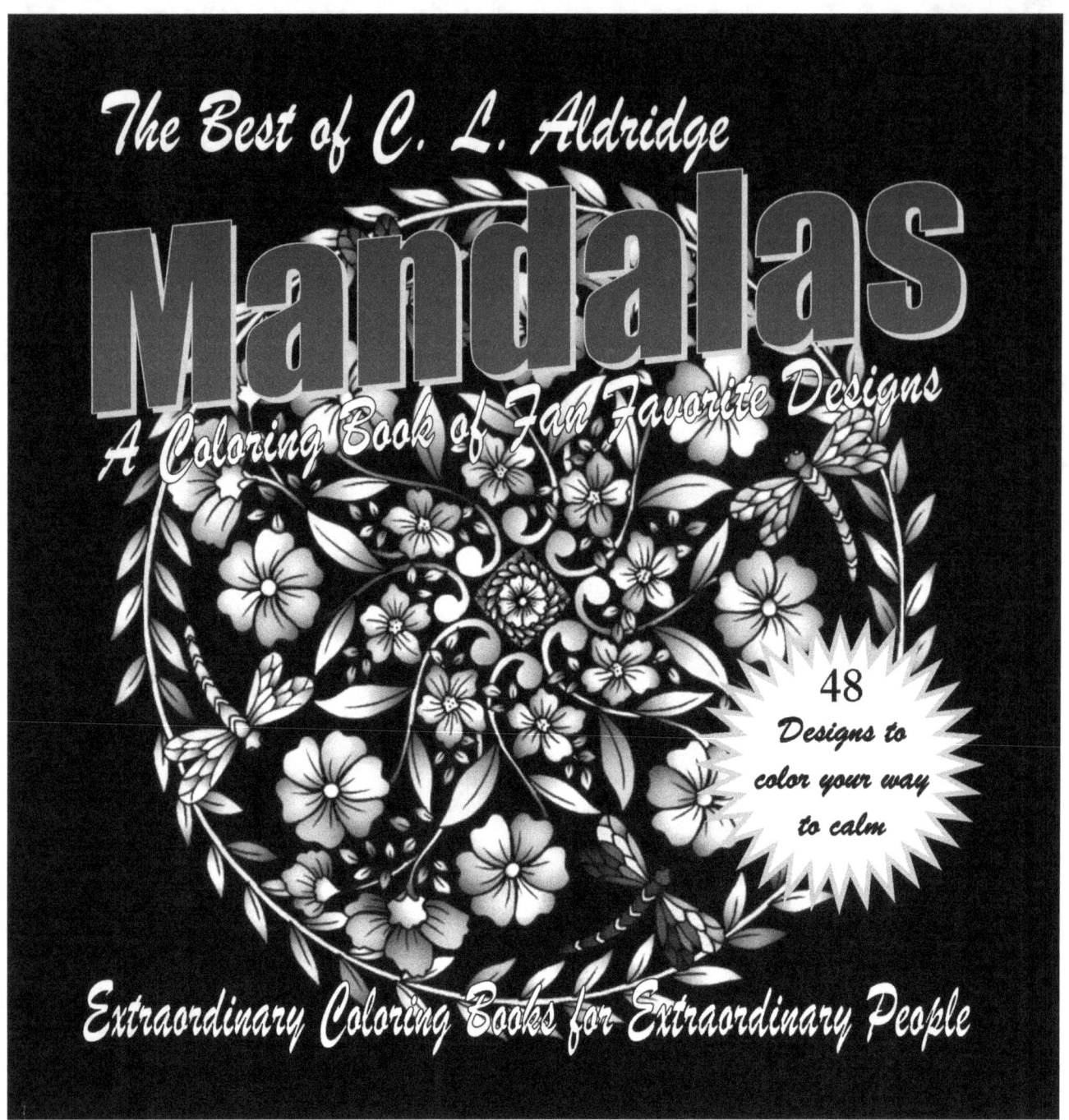

BOOK #10 - BRAND NEW RELEASE

AVAILABLE NOW AT AMAZON WORLDWIDE

OR AS A PDF Instant Download at:

www.Etsy.com/shop/CLAldridgeArt

Extraordinary Coloring Books for Extraordinary People

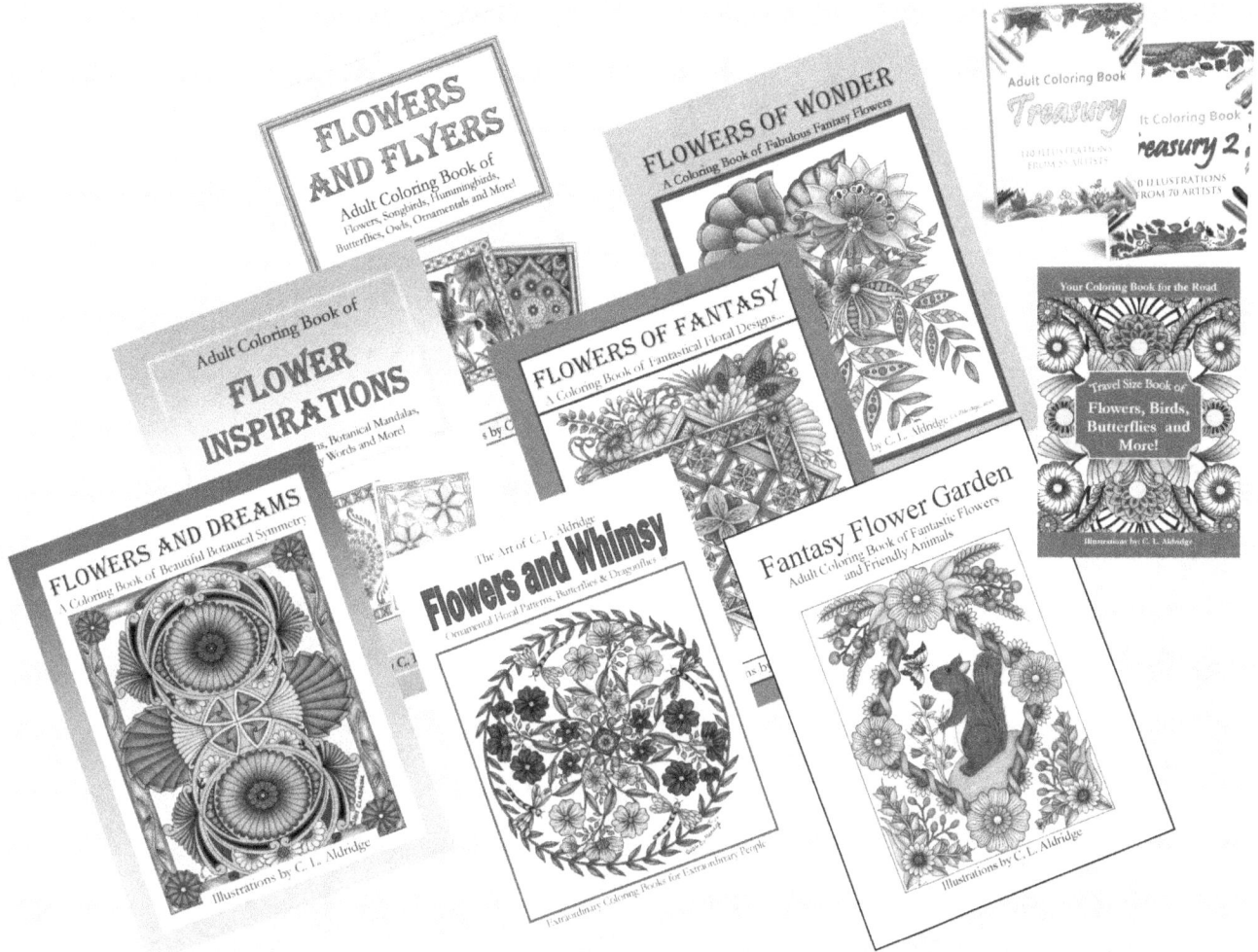

Available in Print at Amazon.com Worldwide
Full Books and Individual pages PDF's Instant downloads at CLAldridgeArt on Etsy.com

FOLLOW ME ON SOCIAL MEDIA AT:

Facebook, Instagram, Google or Pinterest as: @CLAldridgeArt

Visit my YouTube channel: CLAldridgeArt

or

Visit my website at www.CLAldridgeArt.com

www.ingramcontent.com/pod-product-compliance
Lightning Source LLC
Chambersburg PA
CBHW080943170526

45158CB00008B/2359